Painting & Drawing Boats

First published 1985
by A & C Black (Publishers) Limited
35 Bedford Row, London WC1R 4JH

First published in North America 1985

by North Light, an imprint of
Writer's Digest Books
9933 Alliance Road,
Cincinnati, Ohio 45242

Library of Congress Cataloging in Publication Data
Huntly, Moira.
 Painting and drawing boats.

 Includes index.
 1. Boats and boating in art. 2. Art – Technique.
I. Title
N8230.H8 1985 751.4 85–7251
ISBN 0–89134–161–7

Typeset by August Filmsetting, Haydock, St. Helens, Great Britain
Printed in Hong Kong by Dai Nippon Printing Co. Ltd

Contents

Foreword

My family has long been connected with the maritime world, and I was brought up on stories of my great uncles who sailed the oceans in sailing clippers to India and Africa, bringing home pieces of French ivory and jade necklaces.

My early childhood was spent in Northern Spain and I remember travelling to England on the S.S. Mauretania and other P & O Line ships which I boarded when they called at Vigo en route from South America. When the Spanish Civil War broke out I and my immediate family were rescued by the destroyer H.M.S. Whitshed and had a memorable and rough passage out of the Bay of Biscay to Oporto. Other members of the family served in the Merchant Navy during the Second World War. Their stories were of survival in the Atlantic after being torpedoed.

My father was a naval architect and marine journalist and this provided me with the opportunity to attend launches and to be shown over various craft as they were fitted out, such as the old H.M.S. Ark Royal and H.M.S. Venerable. I remember standing in awe at the vastness of the flight deck of these huge aircraft carriers, they appeared to be unsinkable but are now, sadly, long since encrusted somewhere on the bed of the ocean.

And so I grew up familiar with shipping talk, and with both a love and a fear of the sea. I started drawing as a small girl and boats were a favourite subject. The combination of figures, boats and rugged coastal landscape fulfils much of what I am instinctively seeking as a painter.

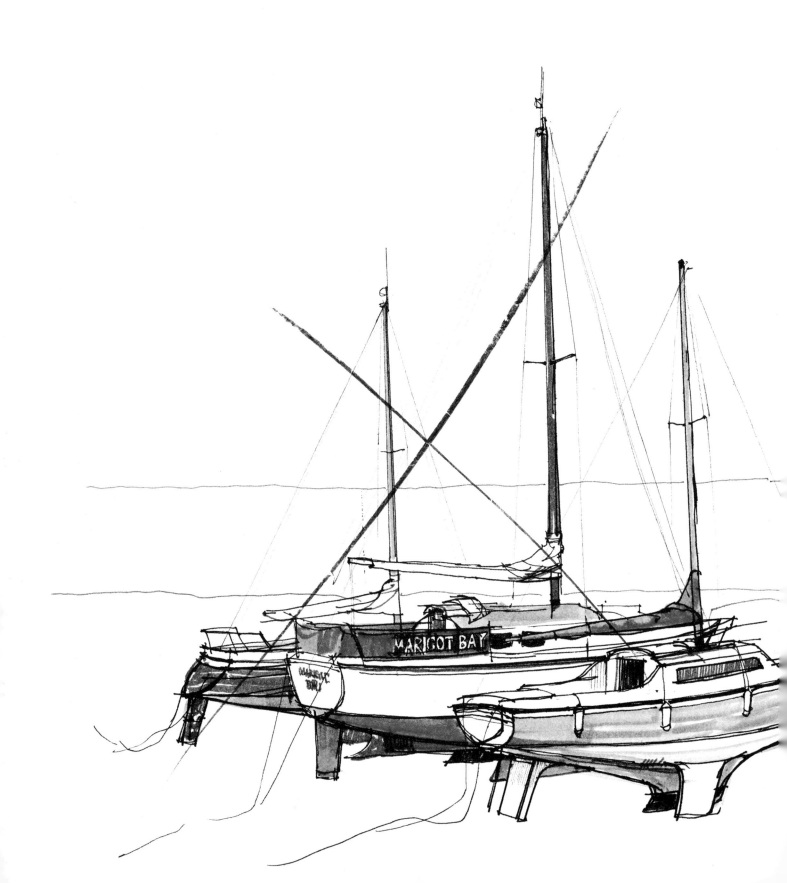

Illustrations

Sketches, diagrams and drawings by the author

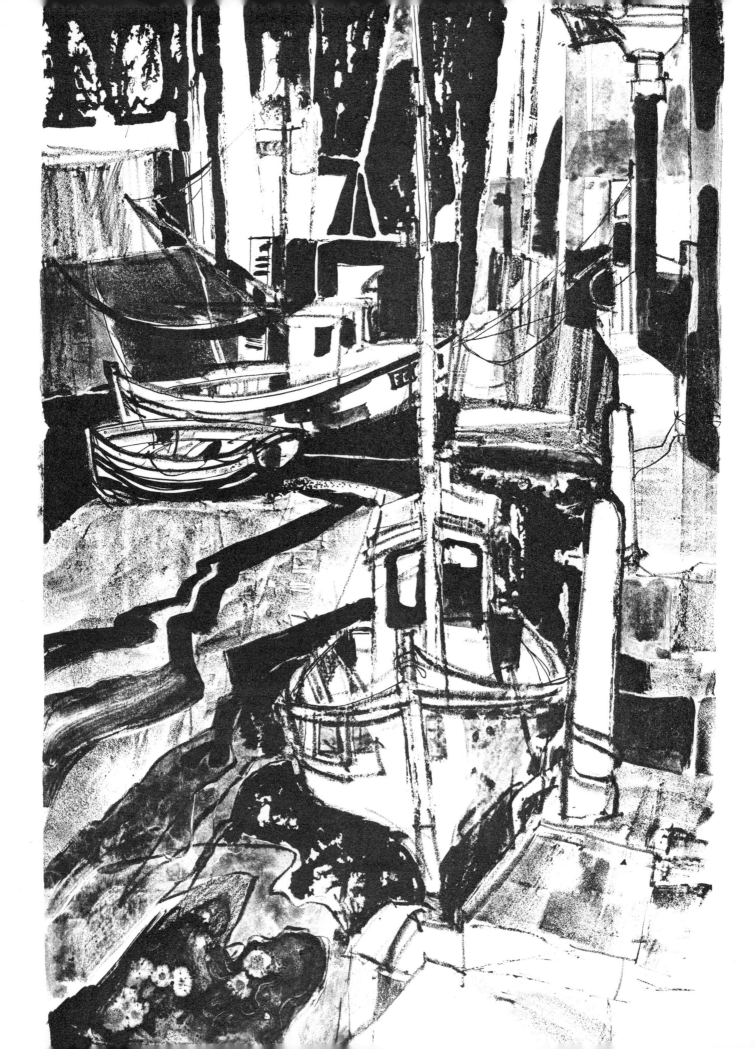

Introduction

Craft of all types fascinate me. As subjects for drawing and painting, I am attracted to boats for the combination of strong definite lines and subtle curves – although these are dictated by the need of vessels to withstand the forces of nature, not primarily by aesthetic considerations. On the other hand, it has been considered 'necessary for a yacht designer to have something of the artist in his make up, because an artistic touch is needed to create a good-looking boat'. (Skene's *Elements of Yacht Design*, 8th edition, page 41: Dodd, Mead, New York; A & C Black, London.)

Drawing and painting boats are basically no different from other kinds of drawing and painting: the beautiful forms of the construction, the complexities of a hull and the often exquisitely crafted details invite careful drawing and precise painting. A knowledge of drawing is perhaps even more important in the case of boats. The skill of construction should engender in the artist the greatest respect, reflected by good draughtsmanship. An accurate drawing need not be dull or dead, it can be a work of art in itself, for boats have a linear quality that ideally suits them to drawing.

This does not mean that all paintings of boats should be realistic. They can also be imaginative in the interpretation of colour, composition or method of application. Abstract interpretations of such subjects are exciting, they stimulate the senses, create atmosphere, or simply provide a visual satisfaction and are equally valid. But abstract painting should proceed from knowledge – artists such as Picasso and Sutherland were masters of accurate drawing.

This book will often refer to the abstract shapes and patterns to be found within a realistic drawing. An awareness of these abstract elements expands the possibilities of interpretation in painting. It is important for a painter to develop and recognise his own vision and to make a personal statement about a subject.

Marine painting encompasses a wide variety of subjects and in this book we shall be concerned and influenced by many factors: colour, atmosphere, natural elements and their effect on man-made objects, the development of imaginative and abstract paintings inspired by the shape of hulls and sails and the dynamic straight lines of masts and rigging. The sea itself is a mobile subject and is difficult to paint, it is also difficult to paint boats on a moving surface, but the land lubber can find plenty of opportunity to paint 'marine' subjects in harbours, rivers and estuaries.

In this book I will mainly describe my personal approach to producing a painting, but I will also describe practical methods of starting a painting by means of step-by-step demonstrations in various media.

Pleasure cruisers in a harbour called for a quick sketch, but however quick it may have been, the drawing still seeks to be accurate. A sketch, however slight, can record the elements that may inspire a subsequent studio painting. The lithograph (opposite) of Whitstable Harbour shows a personal interpretation derived in the studio from a rapid 'on the site' sketch (seen on page 33). Much of the lithograph is abstract in nature, and combines very strong abstract shapes with literal renderings of some chosen features which impart a sense of realism to the work. For example, the top of the print is made up of strong dark and light shapes which in themselves are not especially descriptive of any particular feature. The bottom left-hand corner is also treated in an abstract manner, although here the particular movements and patterns are suggestive of rippling water and reflections.

Throughout the print I have designed light verticals – the tall masts and the bollards – to form echoing shapes which are repeated in a counterchange of light to dark by the vertical posts in the top right-hand corner.

A large amount of the image is treated in these abstract terms, and the boats are almost the only literally rendered objects.

My aim was to produce a harbour scene unquestionably portrayed as such, yet giving my imaginative processes full scope.

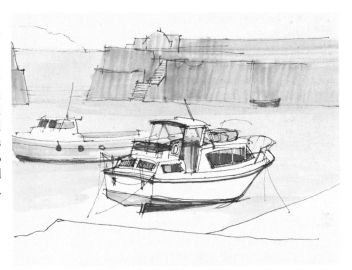

Whitstable, lithograph, 20 × 13 in

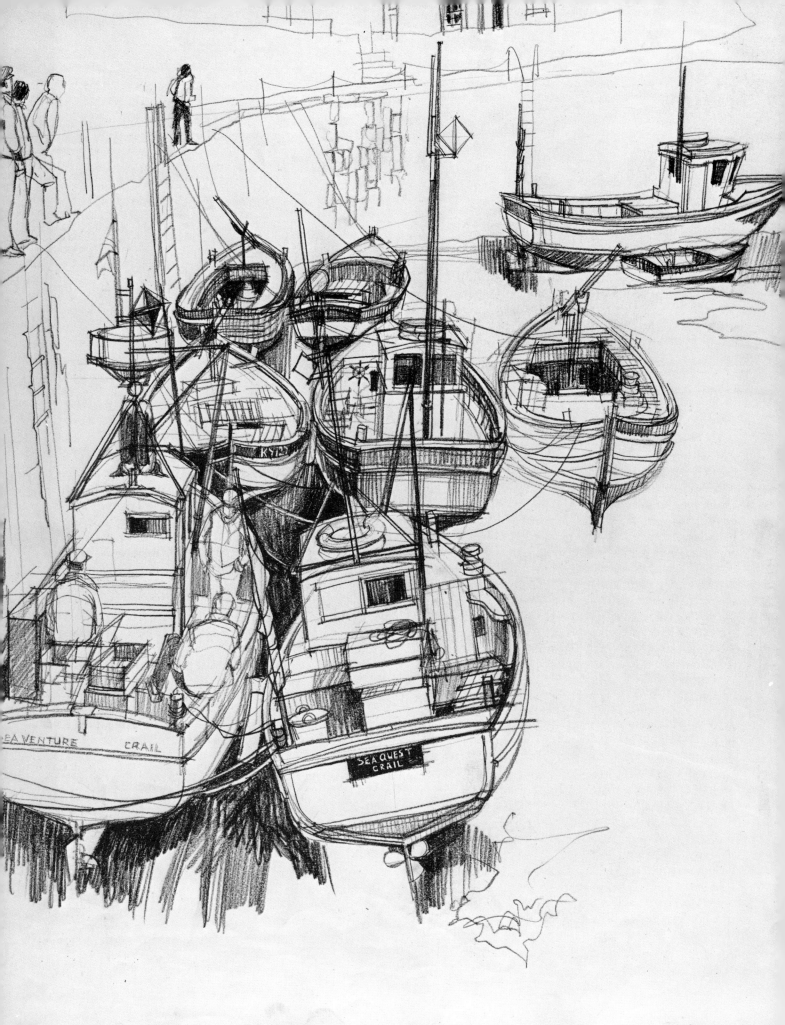

SEA VENTURE CRAIL

SEA QUEST
CRAIL

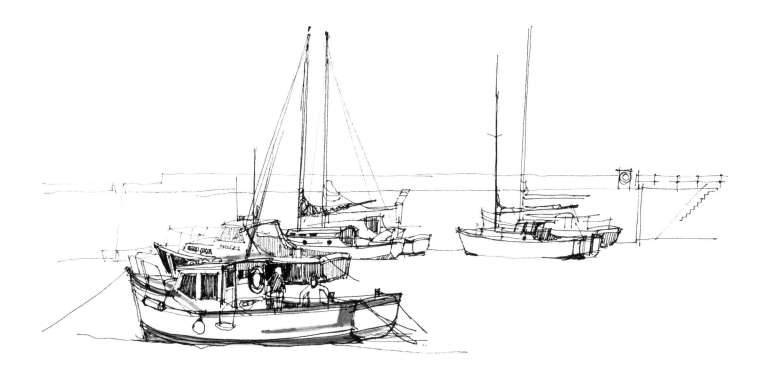

Anyone wanting to draw and paint boats has to be prepared for the elements. This is particularly true of drawing as painting can be done indoors from drawings made earlier. Many of my sketches for this book were drawn under the most difficult conditions: gale force winds, cold, damp or drizzle. An artist cannot always wait around for the right weather. Unsteady lines in a sketch are not important – the main object is to seek information, and sometimes a few unexpected blots and splodges can enhance a sketch! I was fortunate that the weather conditions were good while I was making this complicated drawing of Crail harbour.

Crail is a fishing village on the east coast of Scotland which, like so many fishing communities, is not as busy as it used to be. When I made this drawing in late September I was lucky to find most of the fleet lying at rest in the harbour as the tide went out.

With a black Conté pastel pencil I started the drawing at the top by lightly indicating the harbour wall, and the three fishing boats furthest from me. I was able to start in this way because I had already 'eyed up' how much space the foreground boats would need on the page.

With practice it becomes instinctive to decide how much to include in a sketch, and to be able to visualise it on the sketch pad before the drawing is begun. The inexperienced may find a view-finder of help in this respect.

Before drawing any of the details on the distant boats, I lightly outlined all the other boats. Because the tide was receding the boats lay at different angles, thereby creating an interesting composition. The boats still afloat had masts which were vertical, while the masts of those boats lying in the mud cut across the composition at varying angles. The drawing became full of movement and abstract shapes.

While I was sketching the men who were working on the nearest boat, some of them started to climb up onto the quay, so I quickly took the opportunity to sketch them again in their new position. It was at that point that I realised that I had taken two hours to complete the drawing and that the fishermen were departing for their lunch.

Most of the detail and strong tones are massed together on the fishing boats. To balance this, there are two areas of emptiness: the muddy bottom of the

harbour to the right and the harbour wall. I omitted any strong shading under the right-hand boat in order to lead the eye gradually into the empty area, and I indicated only a small amount of detail in the harbour wall in order to create another transition from the empty part of the page and the busy area.

The other rather obvious point is, of course, that this selectivity concentrates the interest on the boats. Too much detail everywhere would have been distracting.

The quicker sketch of yachts in Saundersfoot Harbour, South Wales, was made with a fibre-tip pen while the tide was in. There was little movement in the water and the dominance of horizontal lines gave a feeling of calm.

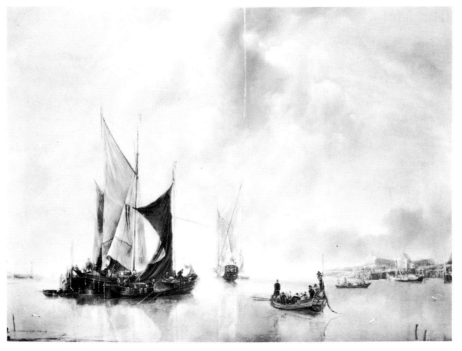

For many centuries artists have sought to portray the unpredictable movement of the sea, the calm serenity of inland waters and all manner of craft. All the paintings reproduced here strongly portray abstract elements as well as visual information.

Jan van de Cappelle (1624–79), who was a friend of Rembrandt, was one of the Dutch painters whose work was to influence Turner over one hundred years later. He was one of a school of marine painters who specialised in creating a feeling of spaciousness and a sense of light in the open air by means of a low horizon and a large area of sky.

The placing of a horizon in a painting is an important factor in its composition. I do not believe that there should be any hard and fast rules in painting, but if there is a dividing line straight across the centre of a painting it can seem as if the composition is cut in half, whereas a dividing line above or below the centre line creates a spatial relationship.

In *View on the Scheldt*, Jan van de Cappelle placed the horizon well below the centre line, and the long low strip of sea gives stability to the composition. The horizon is broken by the boats and shoreline, and the water seems to thread between the boats to meet the sky. This zig-zag movement is discreetly echoed through the pattern of cloud. Notice how the cloud is painted larger and darker towards the top and is made to taper downwards towards the horizon to accentuate the effect of distance.

Distance is further emphasised by the strong dark of the nearest sail, whose flat decisive shape provides strong contrast with the receding atmospheric sky. The smaller boats make secondary dark accents and their triangular placing again points towards the horizon. From the light and airiness of the painting it is not difficult to see how many of Turner's paintings were influenced by the Dutch painters of this period.

The work by Turner (1775–1851) which I have chosen depicts the sea in a very different mood from that of Jan van de Cappelle's painting. Turner captures

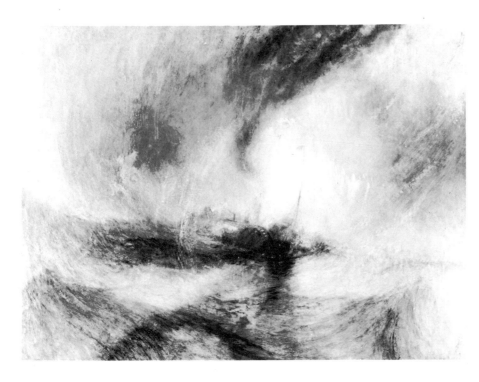

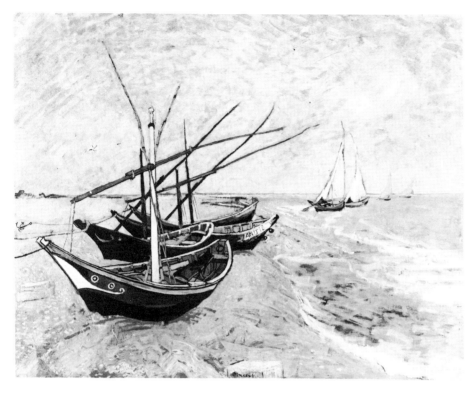

the violent movement of the surging sea in his painting of a steamboat in a snowstorm. The images are powerful as befits the elements depicted. Our eyes focus on the 'still' point in the composition surrounding the bending mast which appears to be in the eye of the storm. Not much of the steamboat is visible, yet we know it is there, battling against the great forces of nature. The little we do see – the precision of the rigging, for example – provides evidence enough of Turner's great draughtsmanship.

Turner journeyed frequently round the coasts of Britain, making brief notes, coloured sketches and many drawings of details. In addition to this preparation, he drew on his superb memory to create sea paintings in the studio. He was a master of the subject.

In total contrast, *Boats on the Beach* by Van Gogh (1853–90) shows a cluster of fishing boats carefully observed, but lively against sand and sky. All seem to point to the 'one that got away'; the vessel about to sail serenely out of the painting. The fishing boats are like a static still life, but are far from being inanimate objects; Van Gogh has given life to something that is still, by his interpretation on the canvas.

Monet (1840–1926), one of the greatest of the Impressionist painters, painted many river scenes. The perpetual activity of people, small boats and moving water attracted him so much that he had a floating studio on the River Seine. Here, he was able to paint 'on the spot' and to study the effects of light on water. He was surrounded by constantly moving light, shimmering colours reflected in water and the broken variations of light effects – perfect for his style of painting. *Bathers at La Grenouillère* is a spontaneous fluid painting with interplay of light and shade, dark figures against the distant light, and light figures against the tree-lined bank. I imagine that I can almost hear the shimmering water lapping against the river boats moored in the shadow of the trees.

National Gallery, London.

13

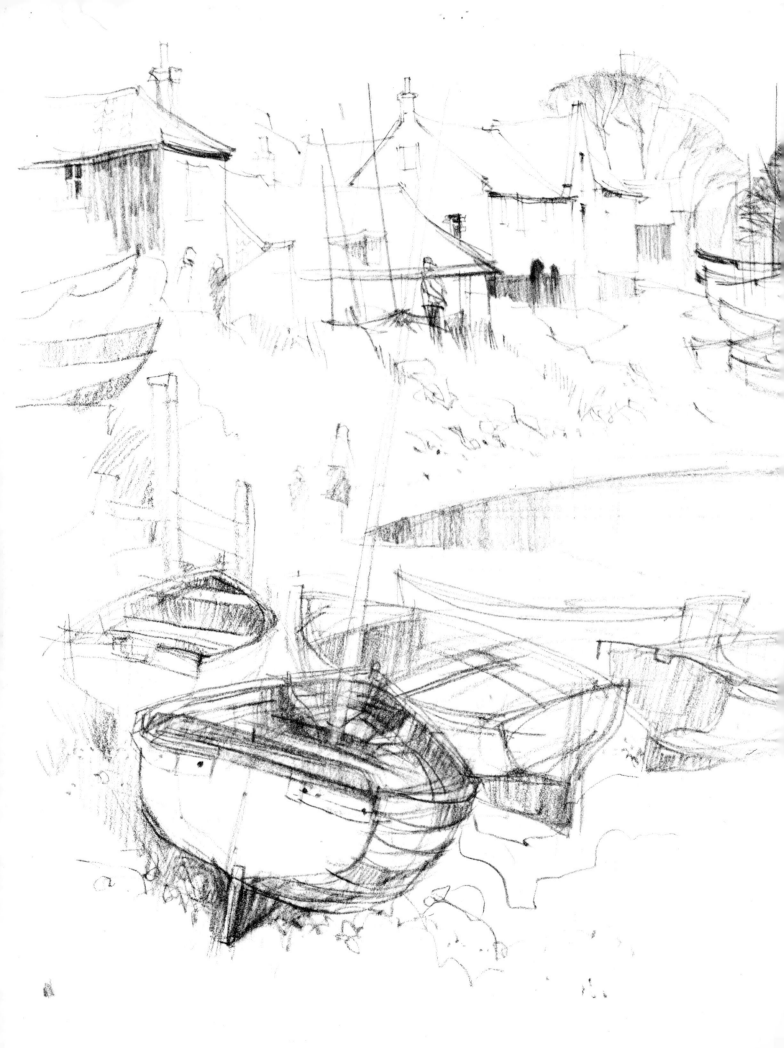

Chapter 1

SMALL BOATS

I often hear the moan: 'I can't draw boats', and I am often asked 'to show how'. In this chapter I will endeavour to demonstrate how to simplify the drawing of a small boat shape. Small boats are not necessarily easier to draw than any other craft, but they are probably the least intricate type to use in illustrating the problems of perspective. The additional perspective problems involved in the drawing of boats with masts and cabins will be dealt with gradually throughout the book, and perhaps be assimilated without too much pain.

Boats have interesting and subtle curves but perspective is necessary in order to make them look 'right'. The drawing should give the viewer confidence in the watertightness or seaworthiness of the boat and allow him to know that he could sit in one safely.

Most of my drawings in this book were made round the coasts of Britain, but small boats are to be found inland as well as on the sea. The beginner who is learning to sail will find it easier to do so on inland waters where there are few currents or tidal movements to create difficulties. Similarly, the beginner wishing to draw or paint boats will find it easier to do so if the boats are lying motionless in still waters. Wherever the boats may be, the difficulties of how to draw them are universal.

Harbours at low tide are ideal places to observe the complete structure of a craft: the shape of the hull below the waterline, the line where the hull joins the keel (the 'backbone' that joins the bow to the stern) and the shape of any keel that projects downwards like a fin. Such knowledge of the anatomy of a craft is an aid to achieving accurate draughtsmanship, particularly so when part of the structure is hidden under water. I liken this to drawing the human body: knowledge gained by drawing the nude and studying anatomy is helpful in understanding the underlying form when drawing a figure that is fully clothed.

Good draughtsmanship develops with constant practice in drawing and a continual study of both the natural and man-made subjects around us.

My Conté pastel pencil sketch of an estuary in Norfolk combines man-made boats with a landscape setting. The calm day and the tranquillity of the water are indicated by the horizontal lines in the distance and the hint of reflections in the water below the buildings. The shoreline undulates in and out and leads the eye into the landscape, it forms a link between the foreground boats and those clustered together in the distance. Few details were indicated on the distant boats and the outlines were lightly registered. However slight the drawing of the distant boats may be, the proportions should look right in order that the boats may take their place within the overall landscape and that they do not create a discordant note.

15

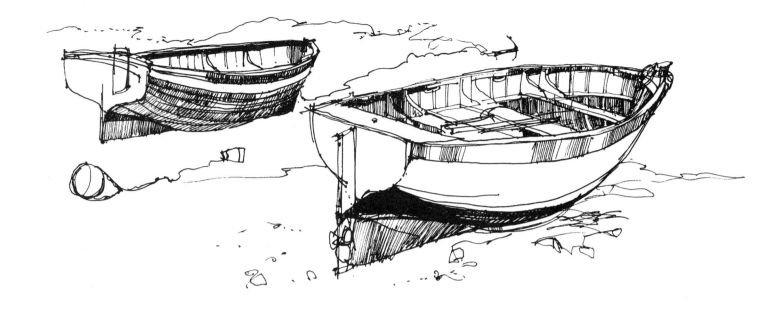

Fibre-tip pen, watercolour and gouache:

Norfolk Boats

Aesthetically, modern boats moulded in glass-reinforced plastic are not usually as interesting to draw as the older wooden clinker type of boat construction. Clinker-built boats have planks of wood attached horizontally along a framework of wooden ribs. Each plank overlaps the next one, and this not only gives strength to the hull, but is of great interest in the drawing.

Both boats in the sketch above were clinker-built and the framework of ribs can be clearly seen on the inside of the boat. The sketch of the nearer boat was not completed, sufficient information having been gained. At the time of sketching, a wind was coming in over the North Sea direct from the Arctic so a rapid drawing was made with a fibre-tip pen. The ink in such pens is not always light fast or waterproof but it flows well for quick sketches that make good reference for painting days in the studio.

The painting in watercolour and gouache started off as an 'on the spot' demonstration carried out on the same bitterly cold October day as the sketch of

two boats. It served its purpose as a demonstration but I decided that it was rather uninspiring as a painting and so it was discarded. After some months had elapsed it came to light in the studio and I reconsidered the painting. Certain elements attracted me, and so I decided to take drastic action and superimpose onto the original painting more positive composition lines in ultramarine blue gouache. Using references from my Norfolk sketches I added extra boats and masts to create a more exciting arrangement, with overlapping boat shapes making a zig-zag movement through the painting. The apparently casual positioning of the masts was done deliberately to give a strong linear and dynamic pattern to the painting. This striving for pattern is also seen where the water makes repetitive curved shapes which, in turn, echo the curved shapes of the boats. I was no longer painting boats as such but was more concerned with the arrangement of areas of tone and colour as abstract shapes – the fact that they were boats became incidental.

Norfolk Boats, gouache, $13\frac{1}{2} \times 9\frac{1}{2}$ in

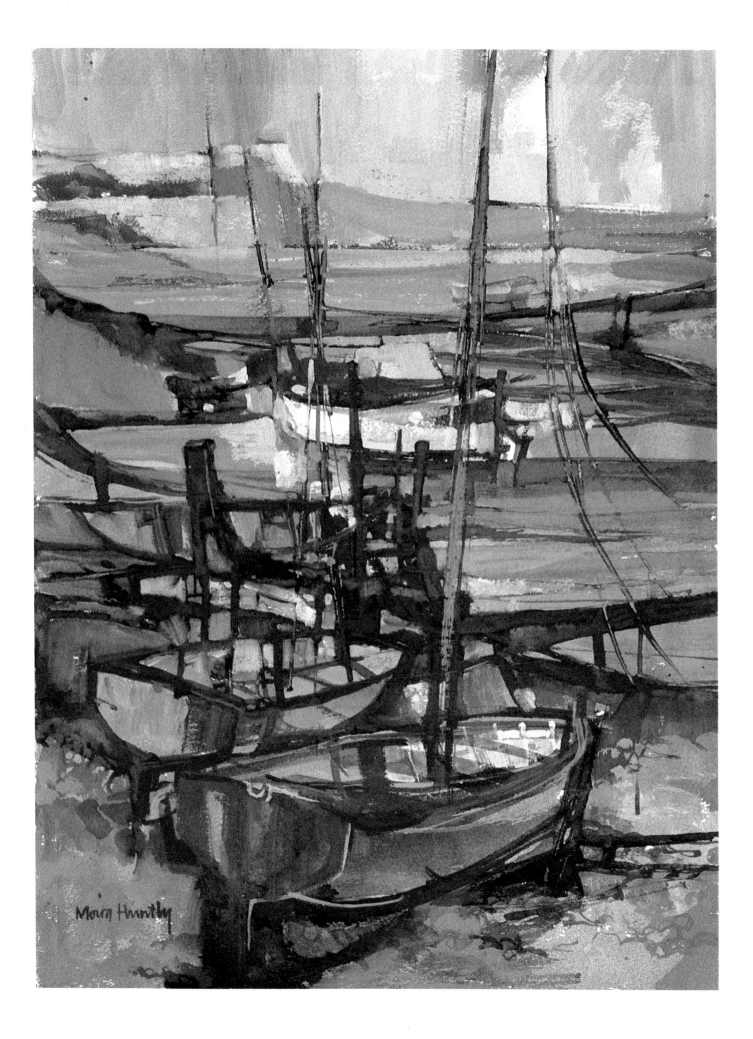

Moira Huntly

Perspective

Perspective gives the illusion of distance within a drawing or painting which has been executed on a flat surface. There are rules of perspective that enable the artist to achieve this effect. Basically the further away an object is the smaller it appears to be; an object at the horizon is further from us and will not be seen at all at that distance. Parallel lines appear to meet on the horizon as they also diminish to nothing. The horizon always relates to the position of the individual viewing it, it always coincides with the level of the viewer's own eyes.

When a simple pointed arch is drawn in a vertical position, it is fairly easy to make the two sides symmetrical with the widest points opposite to each other as in Fig. 3. I find it easier to draw a boat if I think of it as a pointed arch lying horizontally, with the widest points of the boat (called the beam) drawn opposite each other.

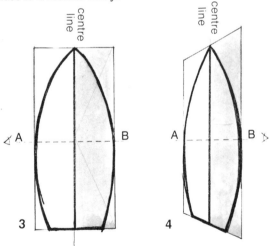

Fig. 1 There is no perspective. The rectangle is divided equally down a centre line. The eye level is in the centre and directly facing me so that side A is the same distance from me as side B and therefore of the same size.

Fig. 2 The rectangle has been turned so that I am viewing it from the side. Side A is now nearer to me than side B and therefore side B appears to be narrower and shorter than side A because it is further away.

Fig. 3 I like to compare drawing a boat shape with drawing a pointed arch. In this drawing of an arch shape, I have applied the same principles as in Fig. 1.

Fig. 4 This shows the pointed arch in perspective, but turned to face the opposite way from the rectangle in Fig. 2. Now side B is nearer to me and it is side A which appears the smaller, because it is further away.

18

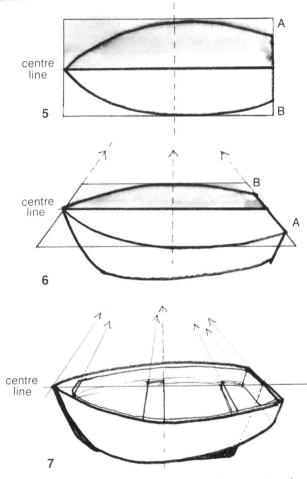

Fig. 5 This shows an arch shape on its side within a rectangle. Side A is of equal distance from me as side B and therefore the same size.

Fig. 6 The rectangle has been tilted so that side B is now further away and appears to be smaller, and parallel lines appear to converge towards the horizon.

Fig. 7 This shows the application of perspective to a simple boat shape. The centre line is lightly indicated and is an essential part of the draughtmanship required for drawing a boat of any type.

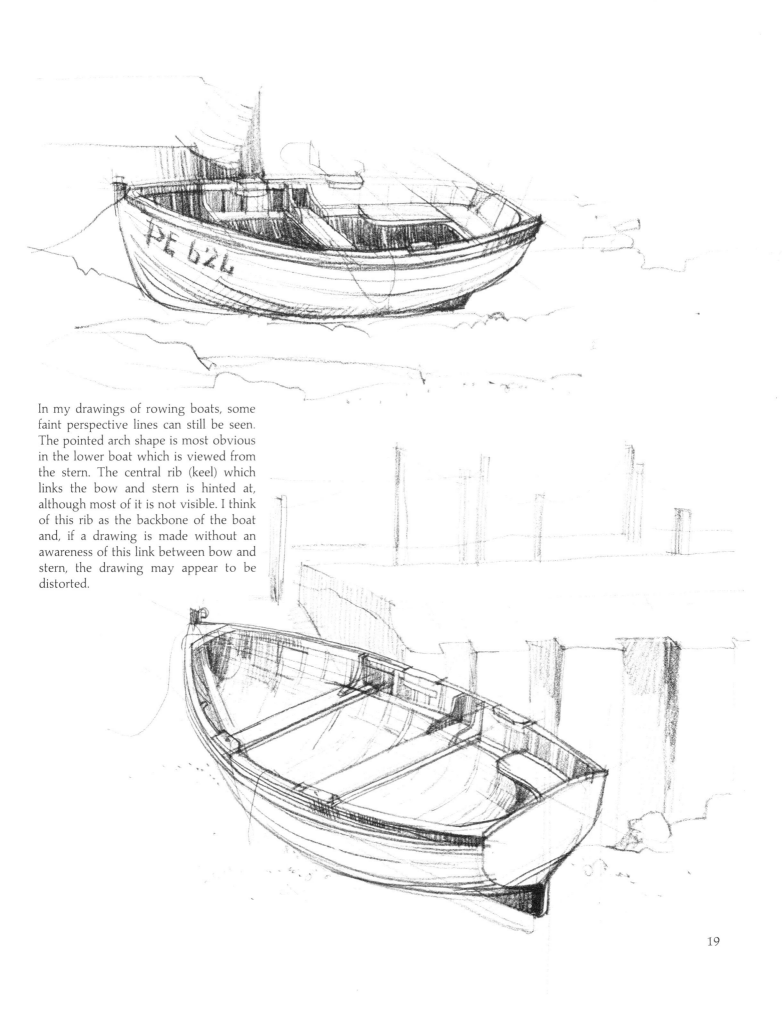

In my drawings of rowing boats, some faint perspective lines can still be seen. The pointed arch shape is most obvious in the lower boat which is viewed from the stern. The central rib (keel) which links the bow and stern is hinted at, although most of it is not visible. I think of this rib as the backbone of the boat and, if a drawing is made without an awareness of this link between bow and stern, the drawing may appear to be distorted.

19

The same perspective principles apply to the transom of the boat, i.e. the stern section.

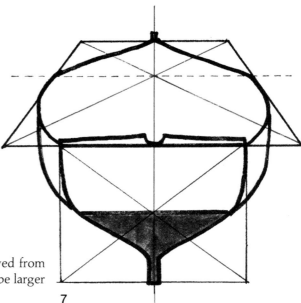

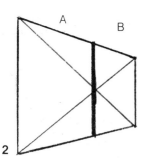

Fig. 1 A simple rectangle is divided equally by a centre line.

Fig. 4 The stern section is viewed from another angle and B appears to be larger than A (because it is nearer).

Fig. 7 The viewing angle of the pointed arch is flattened further, the stern section is added, the side pieces are added and the diagrams are transformed into a boat.

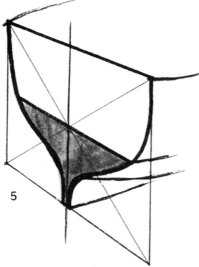

Fig. 2 The rectangle is turned and viewed from the side. The centre line no longer appears to be in the centre because side A is nearer and therefore appears to be larger than side B.

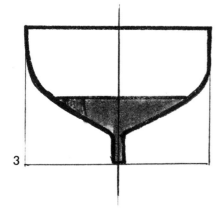

Fig. 5 Looking down on the stern section from another angle.

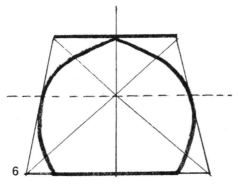

Fig. 3 The stern section (transom) with a centre line making an equal division.

Fig. 6 This reverts to the diagrams of the pointed arch page 18. Here the arch is viewed from another angle and the top half appears much smaller because it is tilted away from the viewer.

20

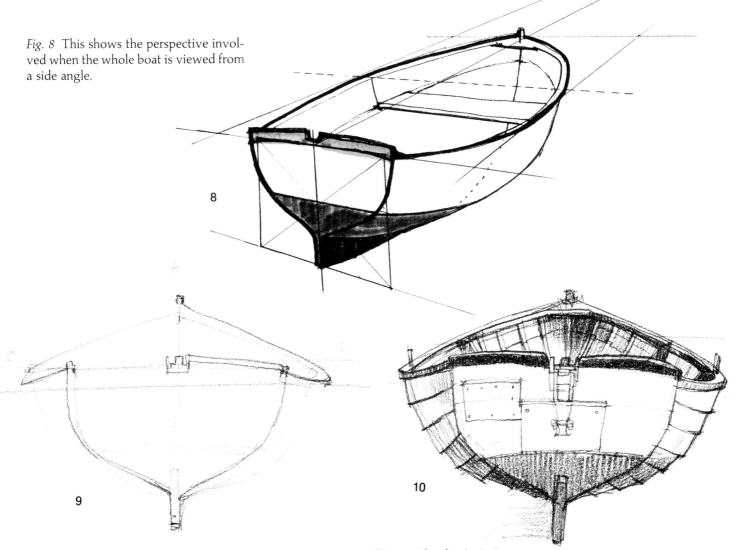

Fig. 8 This shows the perspective involved when the whole boat is viewed from a side angle.

Fig. 9 This shows the subtleties of an actual boat as compared with the diagram in Fig. 7. Here it is viewed almost directly end on. The drawing begins with light lines to establish the relative height and width of the boat and the shape of the hull.

Fig. 10 The finished drawing in Conté pastel pencil of this clinker-built boat records the details for future reference.

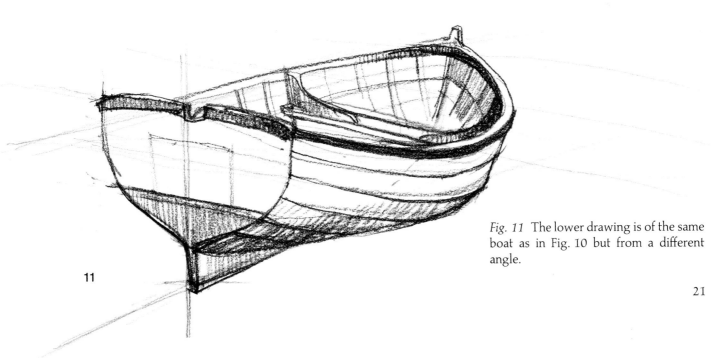

Fig. 11 The lower drawing is of the same boat as in Fig. 10 but from a different angle.

21

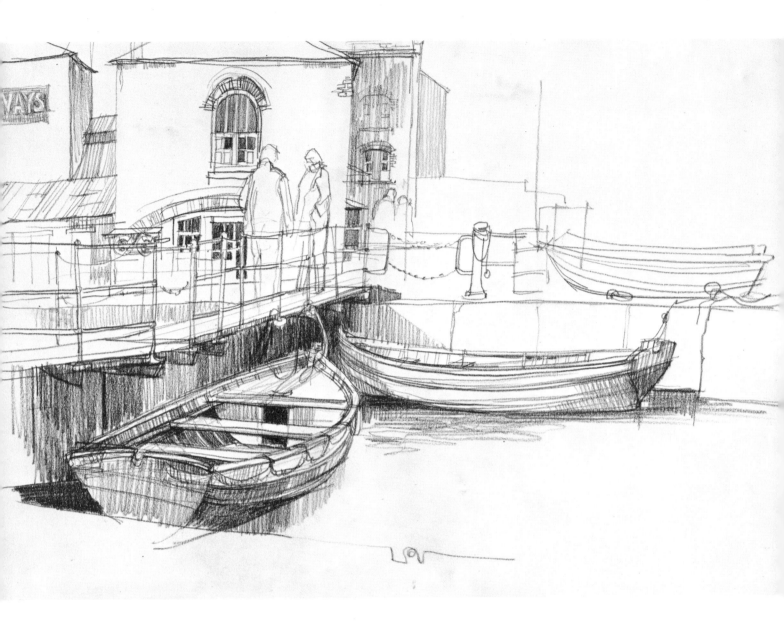

Sketchbook drawings

Another Conté pencil drawing of some moored inland boats underneath the lock gates in the basin at Gloucester docks. On this occasion I discovered that there was a constant movement in the water as the lock gates were gradually allowing water through. The foreground boat was swinging imperceptibly at first, a movement that would not be noticed by anyone who was not occupied in the process of drawing. The first tentative lines of perspective were altered several times before I realised that it was the boats that were moving, and not my judgement at fault. The level of the water was also gradually going down, which was frustrating at first, and which made speed in the drawing of the simple outlines essential. Once these basic proportions are established, the details can be drawn at leisure even if the boats are changing their position slightly. The quick loose sketch of the passing figures gives scale to the boats: the height of the figures is quickly compared with the height of the rail, the buildings beyond, and the length of the boat. These comparisons have to be made very rapidly before the figures pass from view.

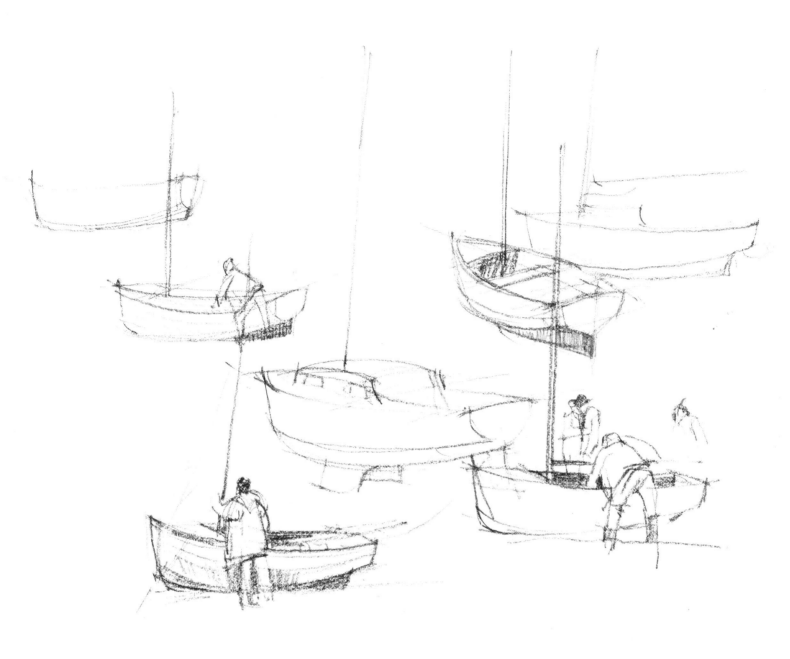

These sketches were made to record a few boats that I saw during a quick visit to a harbour in North Wales. Although sketched in a loose free manner they attempt to record the proportions and forms correctly. Notice that they were all started with free flowing curved lines to register the varying angles and direction of the boat structures, then the shapes of the craft were strengthened.

Sometimes these quick spontaneous notes contain a vitality not found in more carefully executed drawings. I was pleased with the figure leaning over the side of the boat on the right.

Step-by-step in watercolour:

Boats on the Shore

My first demonstration painting is in watercolour with transparent washes, a traditionally English technique. This is a difficult, elusive but magical medium and one where there can be great diversity of effect.

It is interesting to experiment occasionally with different colour palettes and to reduce the colour scheme to the three primary colours. Such a scheme can have variations depending on the combination of the particular yellow, red and blue that are chosen. Lemon yellow, alizarin crimson and cobalt blue will give a different effect when mixed from, for instance, the combination of yellow ochre, vermilion and prussian blue.

Various sketches of boats were gathered together and used as information, from which I created my own arrangement on the paper. I often work in this way, producing several paintings on a theme by making different compositions from the same group of sketches.

Stage 1 I drew the boats with a B pencil, using a simple outline and keeping the detail to a minimum. Attention was concentrated on the arrangement of the boats and their overlapping. A very fine pencil line was used to indicate the horizon.

A dilute wash of raw sienna was quickly brushed all over the paper with the large no. 12 sable. Before this was dry, horizontal brush strokes of cadmium red were stroked across the paper to blend softly with the first raw sienna wash.

Stage 2 I strengthened the cadmium red washes on the background still using the large sable, and waited for the paper to dry before painting the boats. Because the paper was dry, the brush strokes produced hard edges, and I used a ½" chisel-ended sable to give the precise edges.

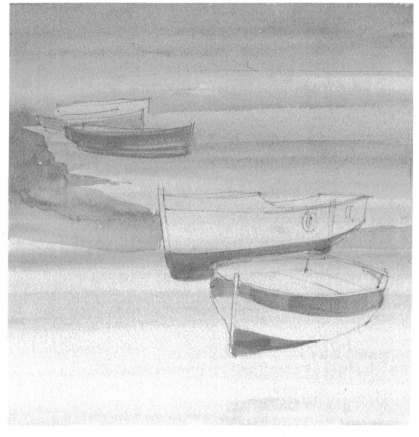

Materials

Brushes: no. 12 round sable
 ½" sable (chisel end)
 Chinese brush
Paper: Bockingford (140lb, 285g/m²)
Palette: raw sienna, ultramarine blue, cadmium red, paynes grey, burnt umber

24

Stage 3 With the no. 12 sable I brushed a wash of ultramarine blue onto the sky, diluting the wash with clean water at the horizon. I continued to brush horizontal strokes of blue across the rest of the paper, softening their edges with a damp brush and leaving streaks of the original pink wash uncovered.

The distant coast was painted with the $\frac{1}{2}''$ sable, in a mixture of ultramarine blue and paynes grey. A stronger wash of these colours was used to indicate the foreground rocks and boat.

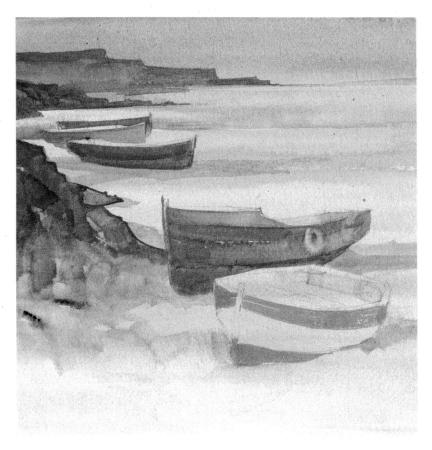

Stage 4 (final) I completed the painting by adding darks, with paynes grey and burnt umber to model the rocks and the boats. Some drawing was added with a Chinese brush to the rocks and to the boats.

I find that a Chinese brush is sensitive to draw with because it gives thin or thick lines, depending on how much pressure is used.

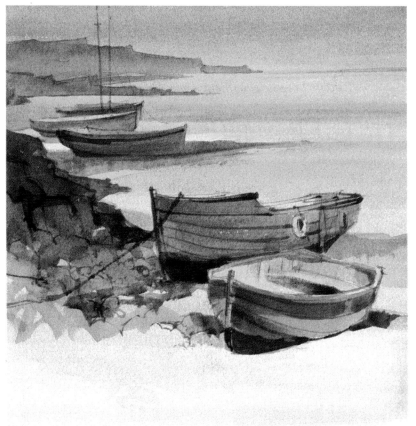

Boats on the Shore, watercolour, $9\frac{1}{4} \times 9\frac{1}{4}$ in

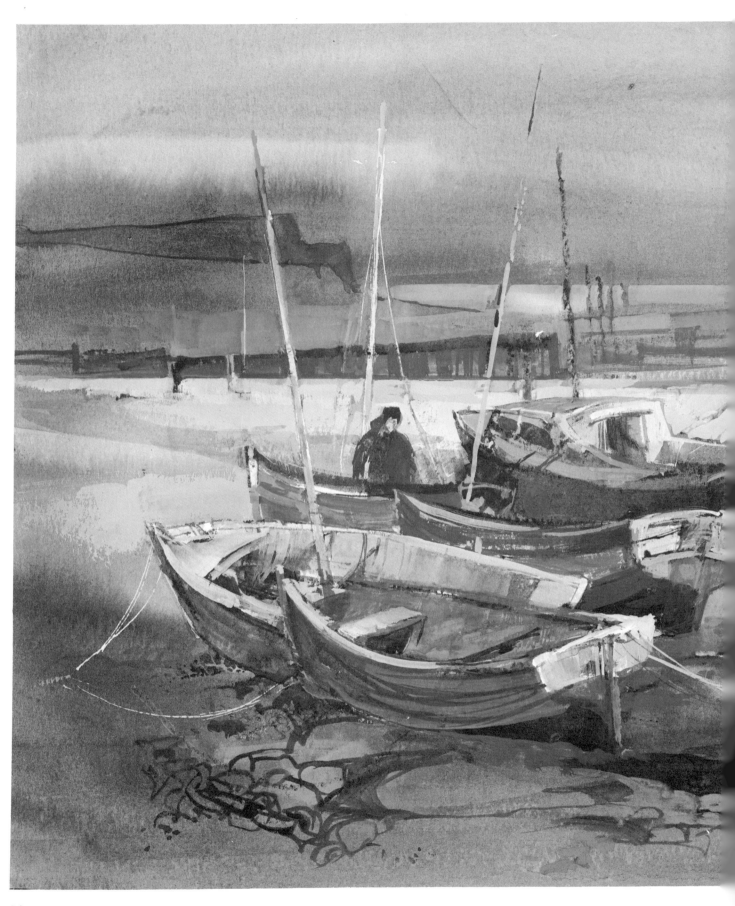

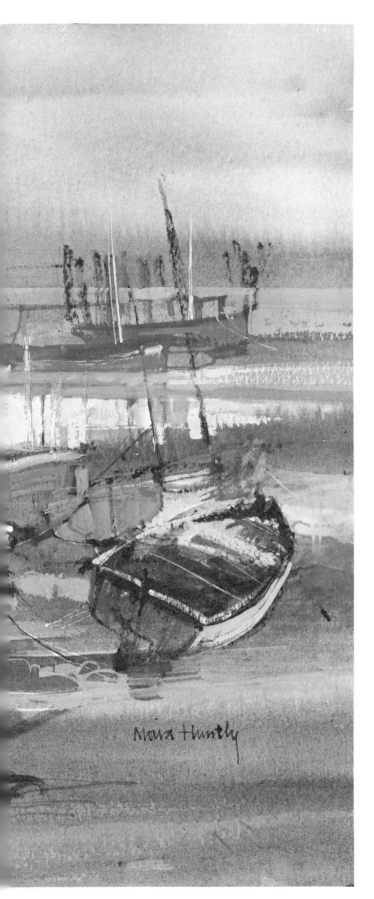

Watercolour and gouache:

Low Tide, Evening

This is painted with watercolour in both its transparent and opaque forms. Both kinds of watercolour are made up of the same pigments, but gouache has the addition of a white filler to make it opaque.

The painting is all about light masts against a lowering sky, the last of the evening light catching the sterns of the boats the ropes hanging idle at low tide.

Under this sky condition the light often appears to be intensified on the water, as shown in the passage immediately behind the boats. This strong light also helps to emphasise the figure and the boats. Always remember that strong contrasts like this are helpful in attracting attention. We should always be aware of such possibilities to draw the viewer's eye to *particular* parts of a painting: lights or darks scattered indiscriminately can appear 'busy' and distracting.

Low Tide, Evening, watercolour, $10\frac{1}{4} \times 13\frac{3}{4}$ in

Watercolour and gouache on tinted paper

On a visit to Overy Staithe, Norfolk, I was interested in the pattern made by the parallel lines of boats and mud banks making horizontal bands across the painting. The masts were deliberately put in at slightly differing angles, but still give some vertical structure to the composition.

The water is also seen as horizontal bands of silvery light and, in contrast, the foreground is broken up into small shapes of sparkling colour. This sparkle is enhanced by the very subtle colour relationships in the immediate foreground and on the left.

Shortly after I made this painting of boats in the harbour at Polperro, Cornwall, a remark was made that it was a pity to have the bottom of the boat cut off. This 'cutting off' was a deliberate and considered action. I am fond of designing a painting where major components in the composition cut straight through to make vertical divisions in the picture area. Here the large boat enters the bottom of the painting with a near vertical line and exits at the top of the painting with a similar off-set vertical line. The post to the right of the boats also cuts the picture area from top to bottom in an unequal division (see in Fig. 1).

The 'cut-off' components in the composition help to focus the eye on the complete component which is totally enclosed within the picture area. My small boat serves this purpose.

The painting is also concerned with simple shapes – circular and triangular. Fig. 2 illustrates the opposing circular movements in the composition, the echoing triangular shapes, some of them dark and some of them light. The mast cuts across the foredeck of the boat and in doing so creates one large triangle and one smaller one. The positions of the two boats create triangular shapes within the area of the water.

The enjoyment and success are in looking for and arranging these repetitive shapes within the picture area without being obvious. Although the painting is of boats, the boats are used as a means of creating an abstract pattern of shapes and tones. The arrangement of this picture is not an arbitrary process but relies on an awareness of repetitions of curves and shapes.

1

2

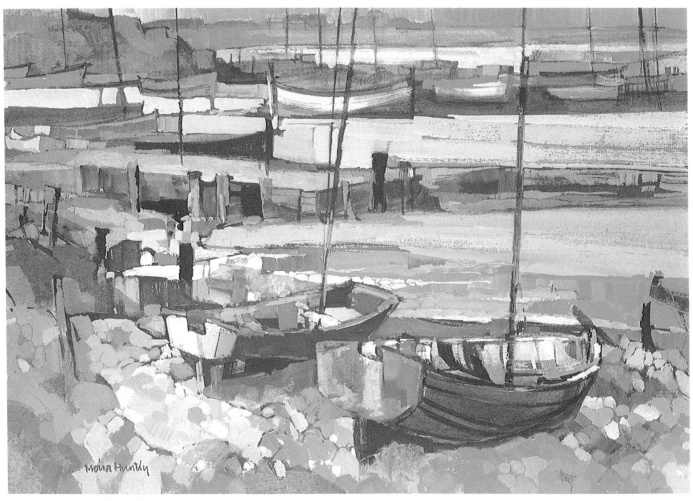

Overy Staithe, gouache, $13\frac{1}{2} \times 19$ in

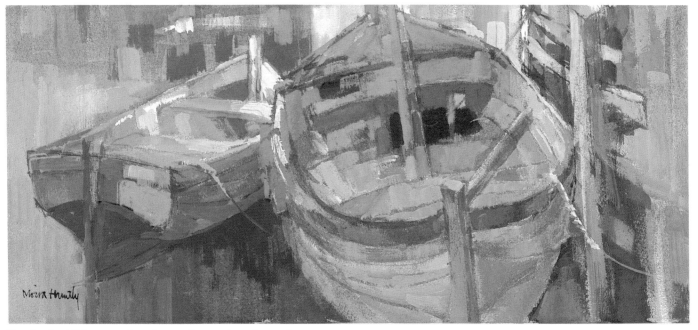

Two Boats at Polperro, watercolour and gouache, $6\frac{1}{2} \times 14$ in

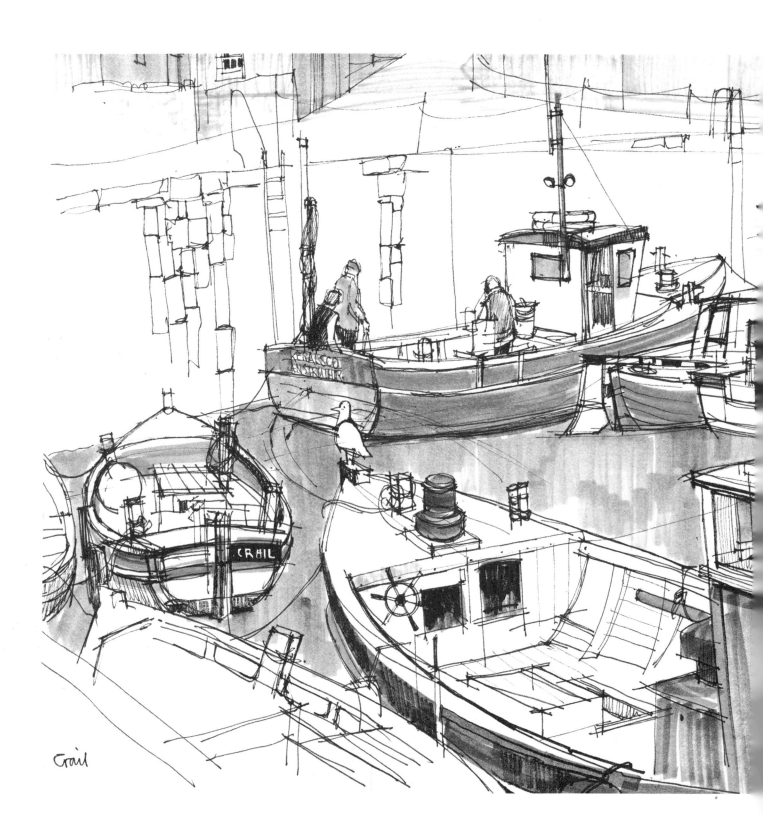

Crail

Chapter 2

FISHING BOATS AND HARBOURS

Seas used to abound with fish and there were vast numbers of fishing vessels. Today the industry is declining along with the number of fish in the sea. Modern fishing vessels are more efficient, more streamlined in appearance and aesthetically less attractive to many painters than the older types of craft. There are still many of these to be found, however, and I became aware whilst sketching in different locations of the immense variety in the design of the hull, masts and rigging. The names given to the various craft, many of which, sadly, no longer exist, make a colourful recital: Drifters, Medway Dobles, Crabbers, the Thames Bawley, Smacks, Shrimp Boats, Trawlers, Cobles, Scottish Fifies, Luggers and Yawls.

Some of these vessels are double-ended in construction (pointed at both ends!) This makes them easier to manoeuvre in either direction, but most vessels have transoms (flat cross-section of the stern) some of which are vertical and some are at an angle.

Fishing boats differ in shape all over the world, with distinctive names too numerous to mention, each with its attraction to painters. Many of the Mediterranean fishing craft have a tall prow, and Newfoundland vessels are sturdily built with square sterns and large cabins.

This quick fibre-tip pen sketch of Crail Harbour (on the east coast of Scotland) shows some of the different stern shapes to be found within one small harbour. Areas of tone, and some colour notes, have been added to the sketch with broad felt-tip pens.

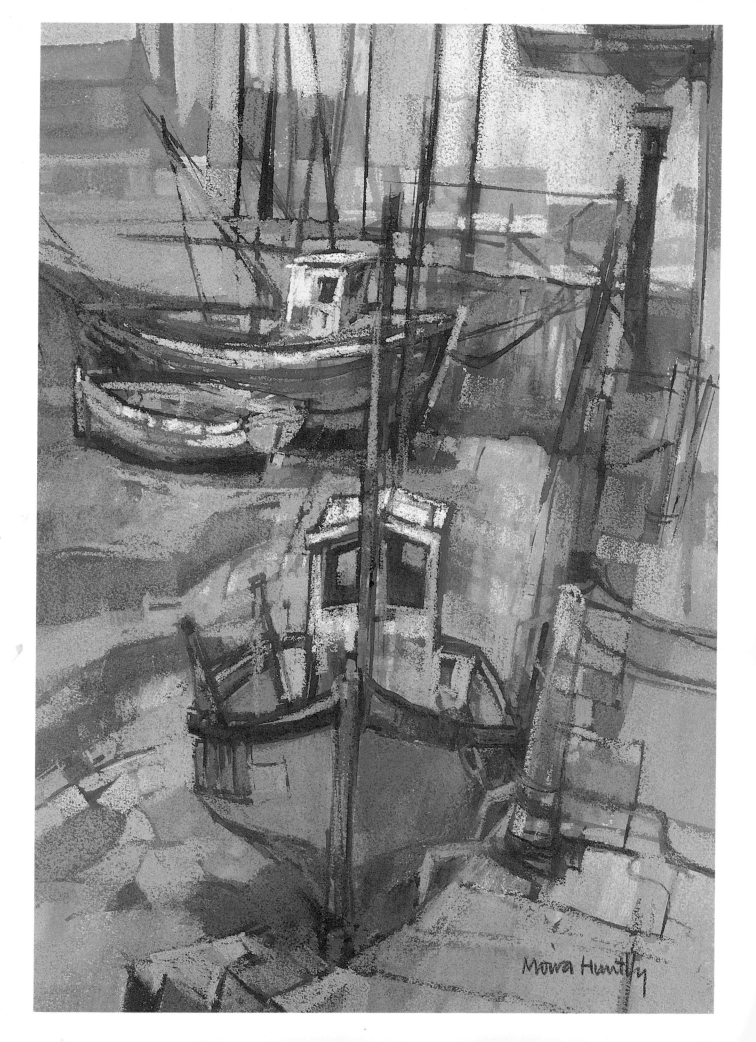

Pencil, pastel and watercolour:

Whitstable Harbour

Whitstable harbour was sketched with speed, hardly taking the pencil off the paper. It was a sunny but cold day in February, and when working out of doors in the winter it is usually necessary to work fast! This is no bad thing, spontaneity can give life to a sketch and convey the essence of the subject with a clarity of vision.

There is enough information contained in the sketch for it to serve as a preliminary study for a painting. In fact, this particular sketch of Whitstable harbour has been the basis for more than one painting, and for the lithograph on page 8. I think this is because the sketch is in itself an arrangement, the composition elements have already been perceived, and it is not just a detailed study for information only.

Once again my fondness of verticals to divide up the picture area have attracted me to this particular viewpoint where the vertical masts are echoed by the vertical perspective of the edge of the harbour wall. The column (top right) supporting the canopy is also an important strong dark, and the swirling movement in the eddies of mud is repeated in the ropes that snake across the quayside.

In my painting of Whitstable Harbour I have tried to retain my original conception, and enlarge upon it.

This is a pastel painting with watercolour as the underpainting. This method has a similarity to the traditional method of building up thick oil paint over a thinner underpainting often described as 'fat on lean'. I like to build a thick slab of pastel onto a base of thin watercolour or thin acrylic paint.

I allow the underpainting to dry and then I can draw onto it and paint over it with pastel, sometimes allowing parts of the underpainting to show through where it is working as an integral part of the painting. Many oil painters, for example Graham Sutherland, allow large areas of thin initial paint and sometimes original canvas to show through. I feel that the method I have used with my pastel painting is the same in principle, although it may be frowned upon by some purists who argue that pastel should be used by itself. On the other hand Degas used pastel in conjunction with a variety of media such as ink and thin oil paint.

This particular painting was started on a stretched piece of light grey Ingres pastel paper, and drawn with a Chinese brush and watercolour. A mixture of hookers green (dk) and ultramarine blue were used for the drawing and for the tonal washes all over. This was the underpainting, and when it was dry, pastel was applied on top. In a few areas of the painting the original watercolour can be seen but deliberately so, where it forms an integral part of the painting. The uneven slabs of stone on the quayside form a varied pattern of rectangles, squares,

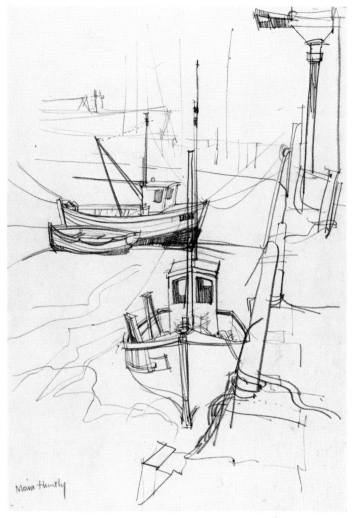

and 'L' shapes. These 'L' shapes are to be found throughout the painting, for example on the cabins, and the bottom of the harbour (seen above right of the foreground boat).

The blues, greens and soft yellows are harmonies, relieved by the subtle touches of warm colour on the prow of the nearest fishing boat, and on some of the masts. A more intense rendering of the same blues and greens is applied to a few chosen areas of the painting and this gives a certain vibrancy.

There is a counterchange of tone with the vertical components of the painting, the masts are light surrounded by a darker tone, and then change to dark surrounded by lighter tones. There is also counterchange within the mast itself.

I was excited by the way that the near masts cut across the bow of the other fishing boat, and by the shapes made by the looping of the ropes mooring the boat to the quay.

Whitstable Harbour, pastel, $13\frac{1}{2} \times 9\frac{1}{2}$ in

Perspective

Basic perspective has been illustrated in some detail in the first chapter and here it is applied to larger more complicated craft. The principles remain the same and, as with all drawing, it is a question of practice and looking hard. With practice it becomes a habit to compare heights, widths and relative positions within an area, etc.

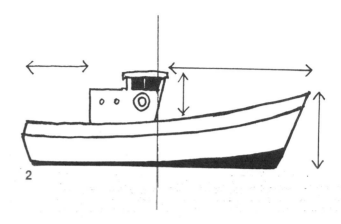

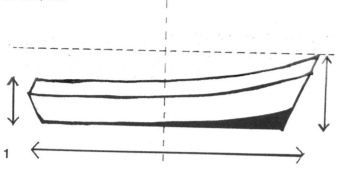

Fig. 1 Here there are two basic comparisons to be made: the visible height of the bow with the overall length of the boat, and the height of the bow with the height of the stern. This helps to establish the curve of the gunwhale (upper edge of the boat's side).

Fig. 2 In this figure there are three more comparisons to be made: the height of the cabin compared to the height of the bow, the distance from the back of the cabin to the stern, and the distance from the fore edge of the cabin to the bow. If observed carefully this should leave you with the correct proportion of the cabin itself. A further check can be carried out by comparing the position of the cabin with the centre line of the boat.

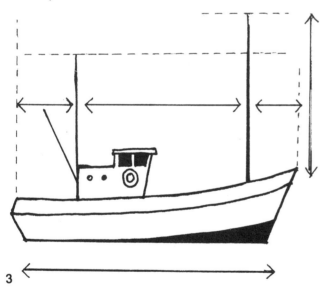

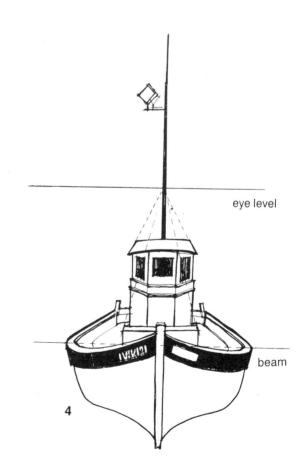

Fig. 3 The visible height of the main mast is compared with the length of the boat, and then the height of the mizzen mast (nearest to the stern) is compared with the height of the mainmast. Look at the intervals between the masts and their position in relation to the bow and stern.

There are no hard and fast rules about these proportions, they will vary depending on the type of fishing vessel which you are drawing, it is a question of individual observation.

Fig. 4 This is a direct front view of the vessel, and I am looking down on the roof of the cabin. Therefore my eye level must be above the cabin. The parallel sides of the cabin top would appear to meet on the horizon (eye level). The gunwhales (top edges of the sides) do not always have the same vanishing point as the cabin sides since they are not parallel to the top of the cabin (see Fig. 4a). Comparisons are made between the height of the mast and the height of the bows, and also with the beam (widest measurement) of the vessel.

4a

Fig. 5 The basic hull of the vessel seen from a 'three-quarter' view. The heavy outline represents the part of the vessel seen above water, and it is important for us to imagine the keel under water which links bow to stern. I have shown the underwater construction with a thin line. It is not necessary to include this in an actual sketch, but just to be aware of the construction. Note that the B half of the transom is slightly narrower than A. All parallel lines are arrowed, and appear to draw together as they gradually converge towards the horizon. Fig. 5a shows the different angle of CD caused by the difference in height between bow and stern.

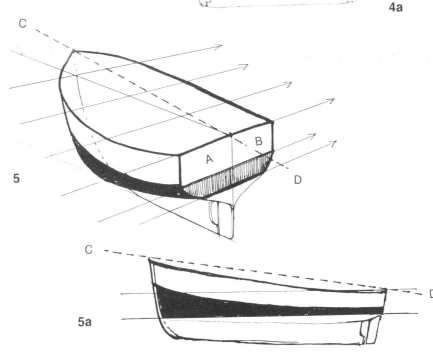

5

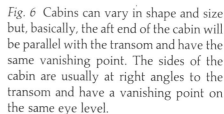

5a

6

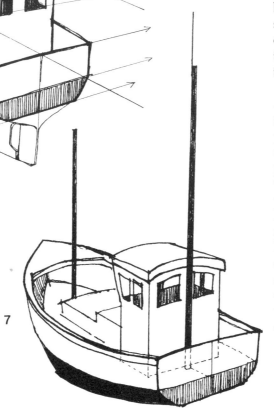

7

Fig. 6 Cabins can vary in shape and size but, basically, the aft end of the cabin will be parallel with the transom and have the same vanishing point. The sides of the cabin are usually at right angles to the transom and have a vanishing point on the same eye level.

Fig. 7 The height of the masts and the intervals between them, are again compared to the length of the vessel, height of the cabin, etc. Line them up in perspective with the centre line of the transom (see dotted lines). The main thing to remember is the unseen centre line of the keel, and that most masts rise from that centre line. Secondly, all parallel lines that are above your head will seem to slope down towards the horizon and parallel lines that are below the level of your head will appear to slope upwards towards the horizon. Horizon and eye level are one and the same.

35

Step-by-step in oils:

Crail Harbour

In this drawing of Crail Harbour, the fishing boats were viewed from above and nearly all with bows foremost. I was sitting down to draw and my eye level was halfway up the high outer harbour wall. The central fishing boat is fairly carefully observed, particularly the height and width of the cabin, compared to the wide beam of this type of vessel. The remainder of the boats were indicated briefly, drawing only the essential proportions and the angles of the masts.

The abstract two-dimensional shapes made by the curve of the hulls and the area of water between, the radar masts and the ropes stimulated my interest in the subject. During the process of painting from this sketch I began to find more and more shapes that were interesting, each part began to relate to the whole and fall into place like a jigsaw.

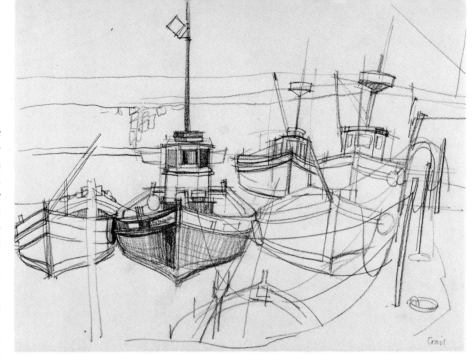

Some sketches work better than others as starting points for paintings, and I cannot always tell in advance how fruitful a drawing may prove to be. It is exciting, when painting from such a sketch, to find that it can lead to the development of many different ideas, and so I will often make a series of paintings that interpret the same sketch in a variety of ways and sometimes in different media.

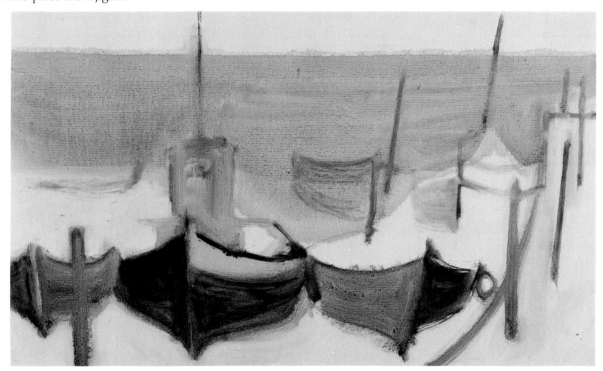

Stage 1 I begin by blocking in broad areas of the composition with a large hog hair brush and thin washes of burnt sienna, diluted with turpentine substitute. Underpainting with burnt sienna, which is a rich earth colour, creates a warmth which will permeate through the painting. The tones of the foreground boats are strengthened and the varying angles of masts and posts are indicated (also with a big brush). I think that it is important to start with the broad masses of a composition – the details can come later.

36

Stage 2 The area of water between the boats I see as an abstract shape, strong and dark, and I block it in with a less dilute mixture of burnt sienna and prussian blue, and in part with prussian blue and raw umber. Some of the boats are reinforced with more tone, and some cool blues are introduced.

While the underpainting is wet it is possible to push it around by wiping out some areas with a turpsy rag, in order to re-create light tones, and other areas in order to re-paint them. Sometimes I draw into an area of thin wet paint with a finger covered with a piece of turpsy rag or draw with the wrong end of a brush.

Stage 3 (final) The underpainting has been left to dry for a few days, and then the final stages of the painting are commenced with undiluted paint. Light tones are built up with a mixture of white and burnt sienna, white and yellow ochre and white added to the other colours

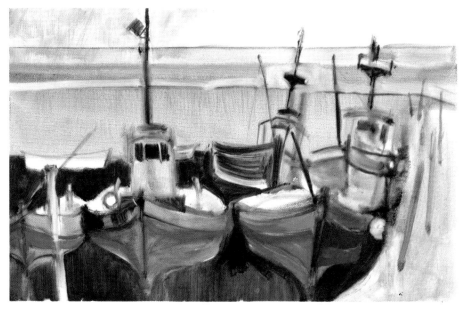

already used in the painting. A surprisingly large number of colours can be obtained by mixing from a limited palette, and a limited palette does give unity to a painting.

As the painting progresses adjustments are made to the height of the posts on the quayside, and touches such as ropes, details on the fishing boats and texture on the quayside, are added.

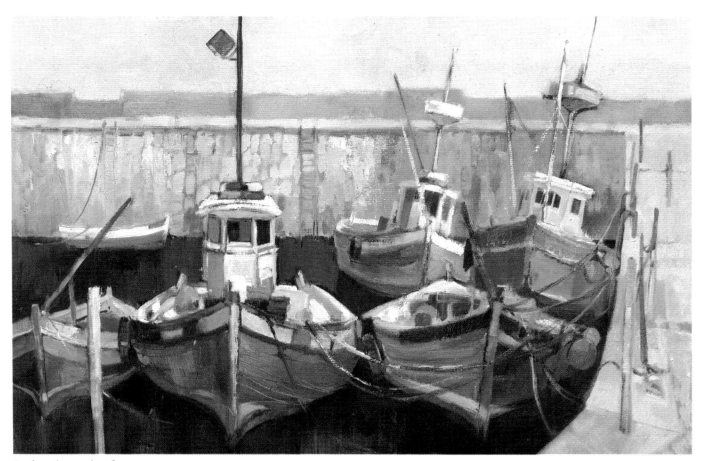

Crail Harbour, oils, $8\frac{3}{4} \times 14$ in

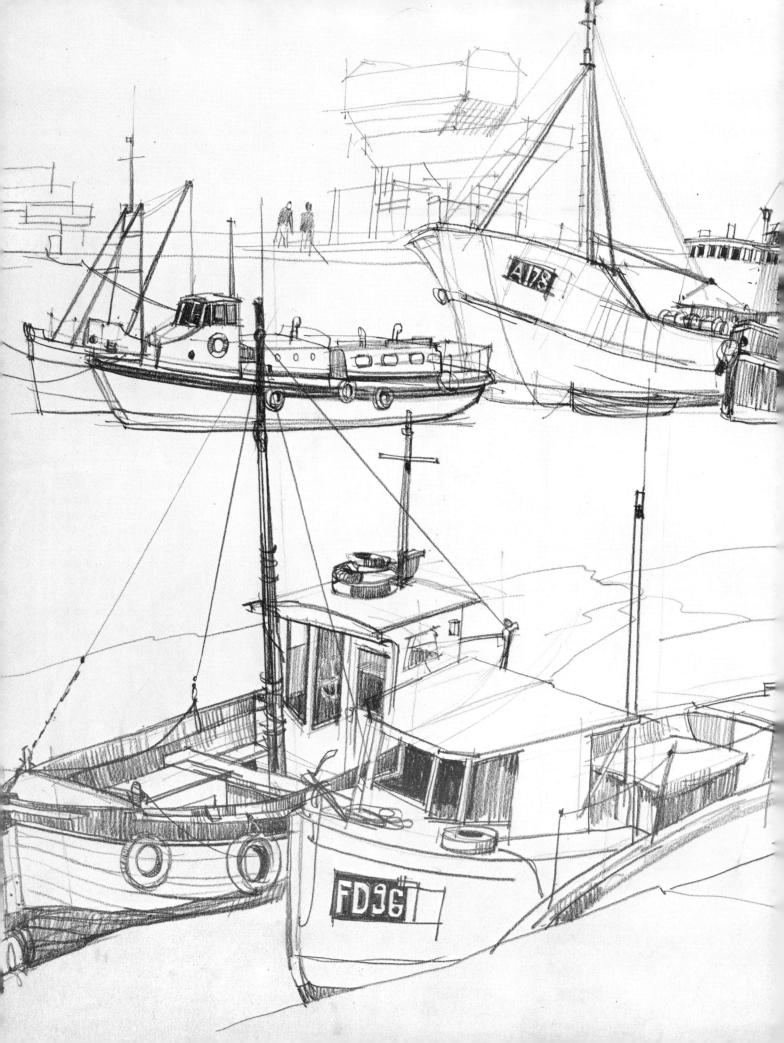

Conté pastel pencil:

Bangor Harbour, North Wales

Good draughtsmanship develops with constant practice at drawing, and to draw boats well, precision and accuracy are required.

Drawing is seeing, and we translate what we see onto a flat surface. The continual practice with hand and eye necessary to an artist can be compared with the continual practice with hand and ear that is necessary to a musician. It is readily accepted that in order to play a musical instrument really well, a musician must practise for many hours every day. It is also true that an artist should constantly practise, there is no easy or magic formula for good draughtsmanship. The magical element is evident or not in the way a musician or painter expresses himself.

In my drawing of the harbour at Bangor, I aimed for as much accuracy as I could achieve, at the same time I tried to emphasise the pictorial aspects that had initially attracted me. I was interested in the linking of two groups of boats to form an artistic whole by means of vertical lines. The masts of the foreground craft are the connecting vertical lines, and the spatial relationship between the masts were an equally attractive element in the drawing. The actual type of boats being drawn were of secondary importance in the overall pictorial conception.

They are of interest, however, as individual craft, and each one is different. In the foreground is a clinker-built fishing boat of sharp-sterned construction, alongside it is one with a wide stern and a cabin which is unusually to the fore. There is an interesting design element about the registration lettering on this near boat, echoed by the registration lettering on the larger craft on the far side of the harbour. The subtle variations of the angle of the bows of each craft, and the curved lines of hull and sail, are all important elements of the finished drawing.

39

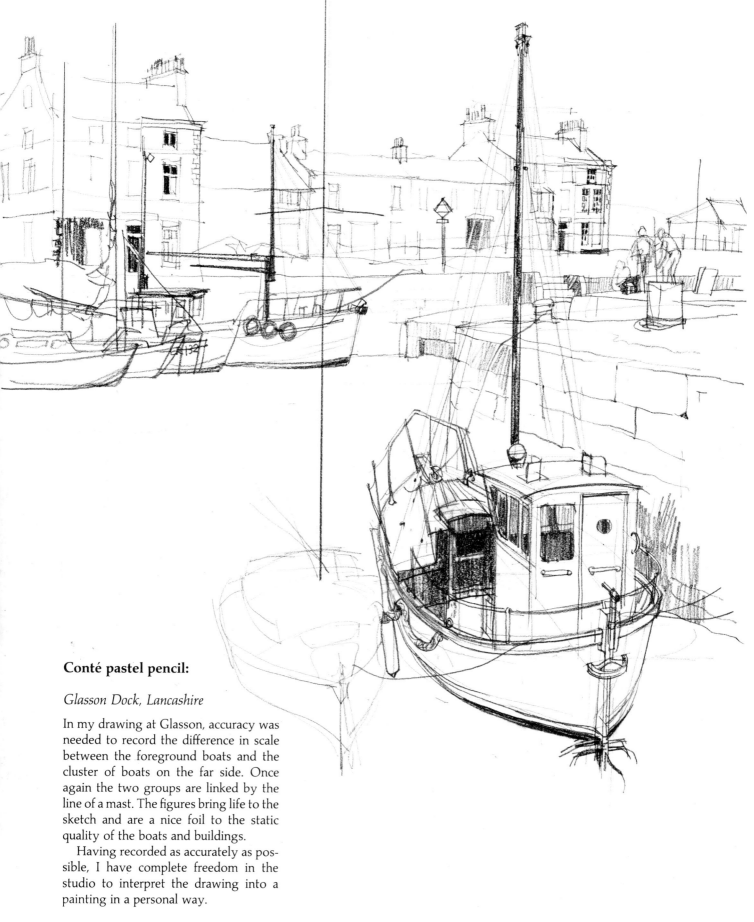

Conté pastel pencil:

Glasson Dock, Lancashire

In my drawing at Glasson, accuracy was needed to record the difference in scale between the foreground boats and the cluster of boats on the far side. Once again the two groups are linked by the line of a mast. The figures bring life to the sketch and are a nice foil to the static quality of the boats and buildings.

Having recorded as accurately as possible, I have complete freedom in the studio to interpret the drawing into a painting in a personal way.

Watercolour and gouache:

Low Tide

This painting started with loose washes of transparent watercolour applied with a large brush. My aim was to establish some of the tonal areas in the composition. The subject was drawn on top of the washes with a thinner brush and blue watercolour. The darkest tones in the composition were intensified with stronger washes of less dilute watercolour.

The information for this painting was put together from more than one drawing, the figure leaning over one of the small boats was taken from a sketch shown on page 23 and the fishing boats from another sketchbook drawing.

Light areas in the painting were built up with gouache, the opaque quality of gouache enabling me to paint light tones on top of dark. The initial dark tones that were wanted in the final painting were left untouched by gouache paint; transparent darks appear to have more depth than opaque watercolour.

In the top right-hand corner, an area of sky has been painted with gouache and a dry brush, which has dragged the paint over the original wash allowing some of the original transparent blue watercolour to show through. Part of the original blue drawing also shows through, particularly in the areas of cool shadow.

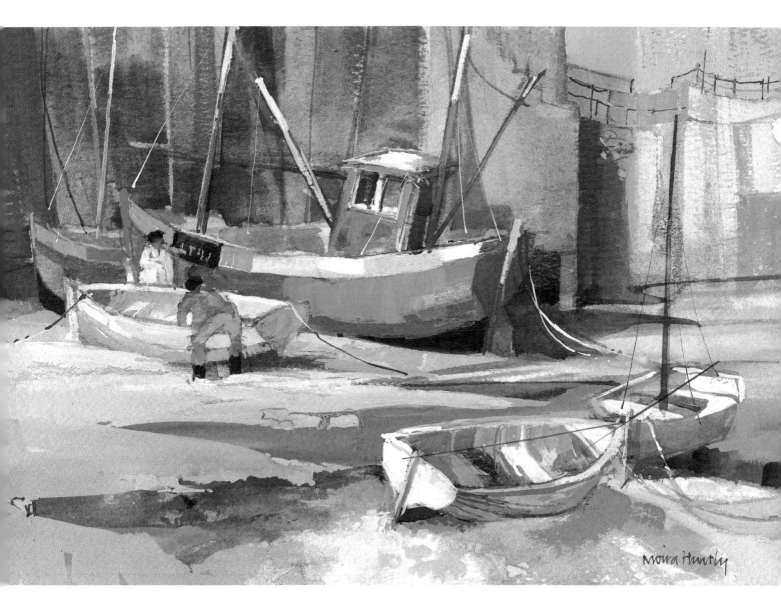

Low Tide, watercolour and gouache, $6 \times 8\frac{1}{2}$ in

Sketchbook drawings

These sketchbook drawings show some of the variety of cabin shapes to be found, so every craft requires individual observation. The rules of perspective always apply, however, and the arrowed lines indicate the underlying construction of how I commence a drawing.

The inclusion of figures where appropriate is useful in giving the scale of a boat. The fishing vessel that moored in the harbour at Littlehampton (on the south coast of England) had an incredibly complicated jumble of apparatus around it, and when a figure appeared briefly on deck I was surprised at how large the figure seemed to be in comparison to the scale of the boat. I had to draw him in quickly, because as soon as he had anchored, he lost no time in rowing ashore in a dinghy.

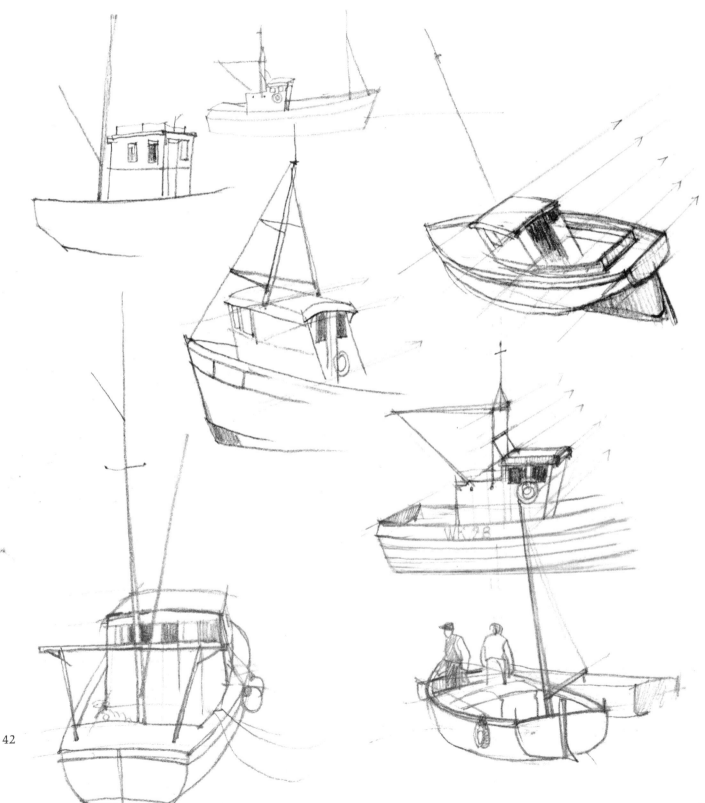

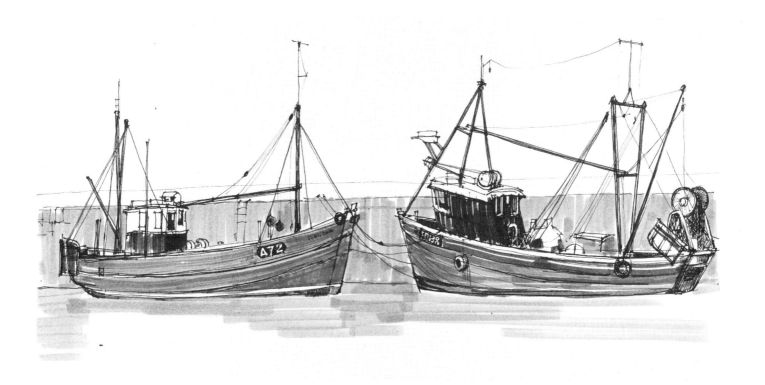

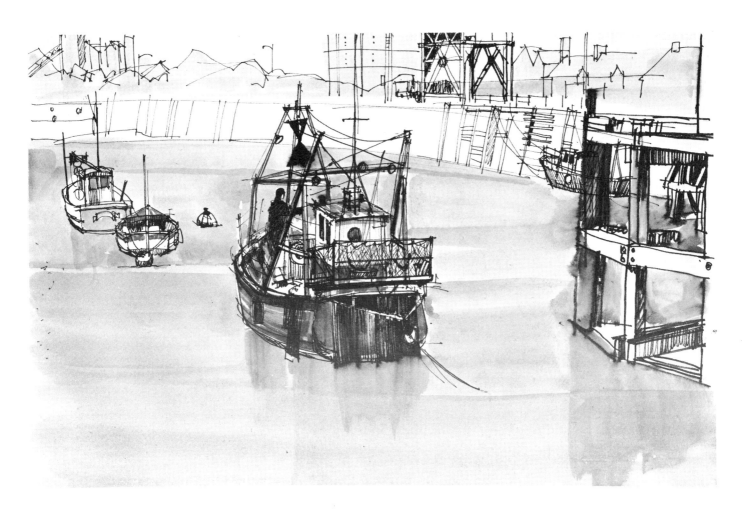

43

Felt-tip pen, gouache on tinted paper:

Bangor Harbour

The painting was based on a sketch made with a felt-tip pen. The tip was broad and the line work almost crude, but when I am eager to record some aspect of a subject, I will draw with whatever comes to hand. The view of the quayside formed a large triangle leading to the figures and this was echoed by the strong triangular shapes of the rigging.

The painting was made on a tinted paper which is helpful when judging tonal values. It provides a ready-made middle tone to which lighter and darker tones can be added. Parts of the paper can be left unpainted so that its self-colour shows as part of the painting. Where you

wish to obliterate the paper colour the paint needs to be opaque. For this painting I used gouache on a sand-coloured paper. The paper colour shows in the background hill and in parts of the boats.

The light passages on the cabin of the nearest boat are painted with thick gouache and are a contrast to the dilute paint on the surface of the harbour water. These rectangular light parts of the cabin are significant in my way of treating the painting. I have built up the painting with rectangular slabs of paint. These are very obvious in the boat cabin, but they also suggest the huts in the background. The

water and the sky are painted with definite, downward rectangular paint strokes. Occasionally I leave lines of paper showing between the brush strokes and these suggest boat masts, spars and posts.

The result of this process is that the spaces between features, rather than the features themselves, are painted. This 'back to front' treatment gives a special character to the painting. A line produced in this way can be more exciting than a more obviously drawn line.

The strong sense of structure is achieved by the combination of slabs of colour, uncovered paper and drawing. I usually start by drawing the skeleton of the subject with a brush and dark paint. If a line is incorrectly placed, I leave it, knowing that I can cover it with paint later or that I can leave bits of it uncovered to look like broken, out-of-focus detail.

I aim to produce a balance of hinted and positive statements – with broken lines, strong lines and echoing shapes of differing sizes. Every statement is considered in advance and then made decisively. In the painting of *Harbour Boats* I have introduced some echoing diagonal movements. The tall building leans, slightly, to repeat the lean of the boat masts. The edge of the quay provides a definite diagonal leading towards the tall building and then turning abruptly into the picture.

The colour changes are balanced with subtle changes of blue, grey and green placed against the brighter pink of the sky. The pink is repeated as bright accents on the boat cabin; and two smaller distant flickers of pink lead the eye in a diagonal direction towards the tall building.

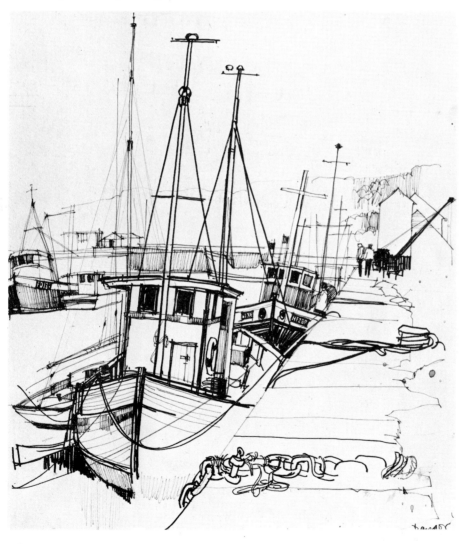

Bangor Harbour, watercolour and gouache,
15 × 11 in

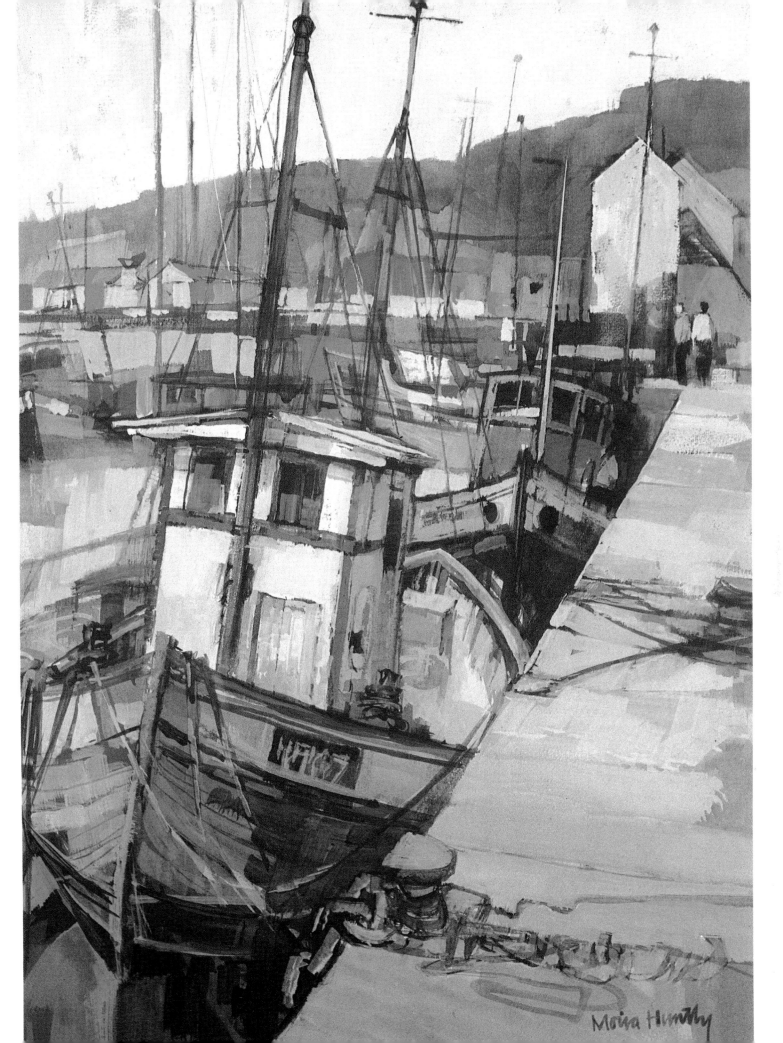

Moira Huntly

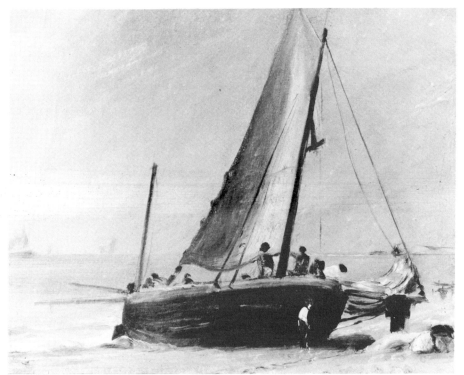

The reproductions of fishing boats that I have chosen are very different in conception and technique. Constable (1776–1837), one of Britain's major landscape painters, was a contemporary of Turner (being only one year younger than Turner). During the eighteenth and nineteenth centuries harbours and ports were packed with shipping and the coasts were bustling with activity, and so it was to be expected that Constable, although principally a landscape painter, would also paint seascapes.

Early in his career he spent a month on board an East Indiaman making many sketches, but most of his oils of the sea were painted from the shore.

Brighton Beach with Fishing Boats and Crew has the spontaneity and freshness of an oil painting made on the spot. Constable represented nature and the elements with a directness and simplicity

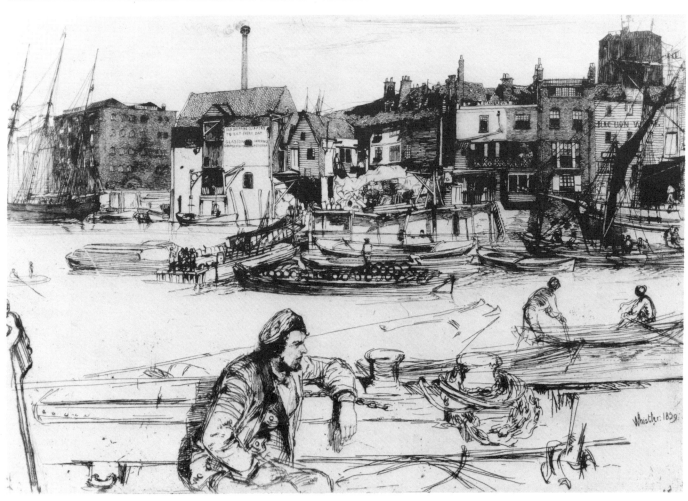

46

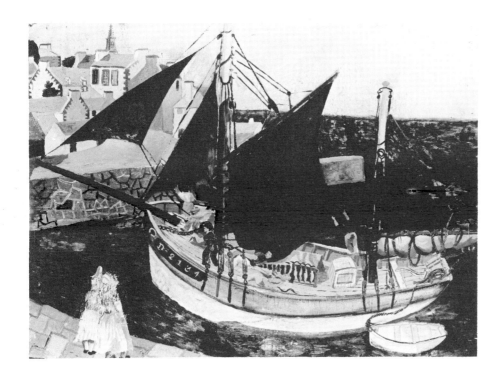

in the tradition of the earlier Dutch painters, particularly the Van de Veldes. In his turn Constable was to influence Monet and the subsequent Impressionist school with his 'plein air' painting. You can almost feel the fresh breeze and hear the breakers, as the crew prepare to catch the tide.

The composition is simple, the boat shape and angles of the masts are well placed and complemented by the simplicity of the distance. It is a painting full of marine atmosphere.

In contrast to Constable's painting is an etching by Whistler (1834–1903), the American painter who studied in Paris, where he met Fantin La Tour and Degas, and was greatly influenced by Courbet.

Black Lion Wharf is one of a group of etchings of the Thames in London, recording everyday activities on the river. The drawing is full of life and contrasts. The simplicity of the foreground and the single large figure are a nice foil to the richness of textures on the buildings. Whistler has included a lot of detail without being laborious; looking closely, I can discern a figure climbing aloft to attend to the rigging of the sailing ship on the left. There is a pattern of solid areas of black and white falling into place between brick and clap board textures.

These spontaneous etchings (many of Whistler's etchings were drawn out of doors directly onto the plate) had an enormous influence on the art of his time. He was not afraid to have empty spaces in his pictures, concentrating on the areas that interested him and leaving the rest only hinted at. This was an unusual idea at the time.

Christopher Wood (1901–30) also went to Paris, where he took up painting and learned to draw and paint in a remarkably short time. He made a big impact in Paris, where he met and was influenced by many of the important painters of his day including Picasso. For much of his short life he imitated other painters, only finding his own naïve vision within the last two years of his life.

It was not until he discovered the ports and harbours of Brittany and Cornwall that his true potential as a painter emerged. They became his favourite subjects and the fishing ports brought his art to fruition. He had a boat and liked to go out and paint fishing boats from it, so that he could look inland and paint a backdrop of coast and trees instead of sea and sky.

Perspective was sacrificed in Wood's paintings in order to gain a child-like simplicity and lyrical quality. In Cornwall, at St. Ives, he met and was immediately influenced by a Cornish fisherman turned primitive painter called Alfred Wallis. Ben Nicholson was also in St. Ives at that time and was affected by the directness of Alfred Wallis's paintings. This was subsequently to influence the development of British modern painting.

Boat in Harbour, Brittany reminds me of the harbours on the east coast of Scotland; they are often small and the architecture is very similar. The painting evokes a feeling for the sturdiness of the fishing boat returning to harbour, with its salt-caked sails. There is also a strength about the pattern of dark sails and rigging against the sky, and the light hull and dinghy pushing through a dark sea. The sea itself as part of a spatial composition has become divided up into a series of visually satisfying shapes. Like Constable's painting, the boat shape and the angles of masts and boom are well placed to divide the horizon.

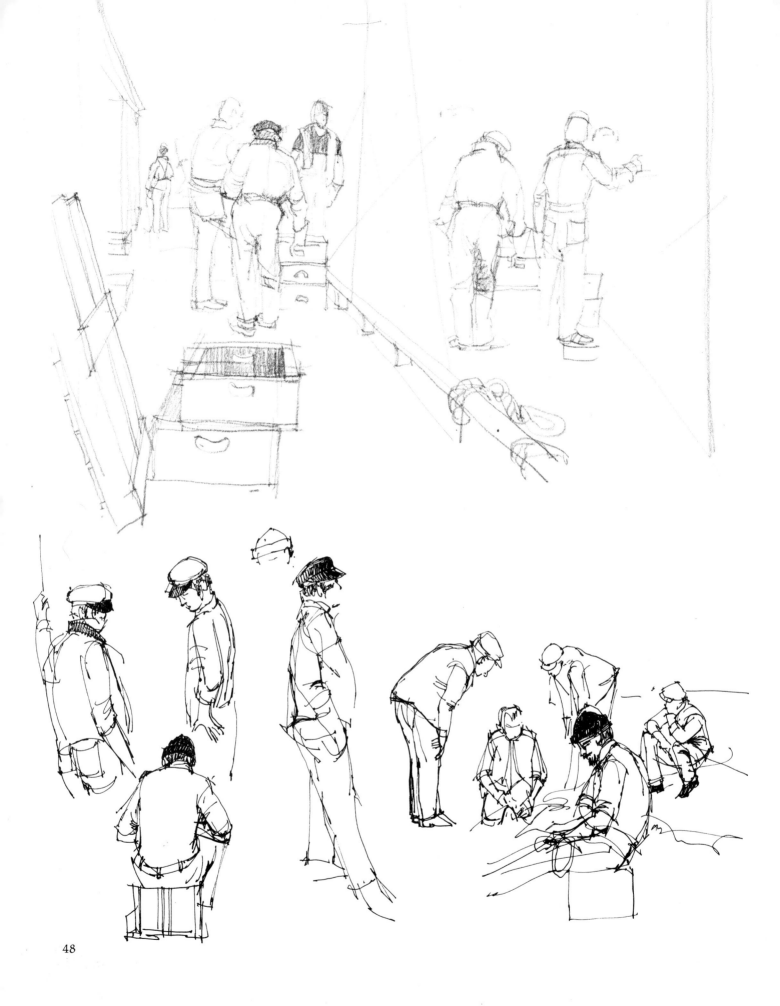

48

Drawing the human figure

The best way to learn to draw is to draw, and the more we draw the more we see. This in turn leads us to realise that there is much more to know about drawing and seeing, ad infinitum. This realisation is both exciting and awesome.

One of the most difficult and at the same time most rewarding of subjects to draw is the human figure. Moving figures require intense concentration. I look hard and try to transfer what I see onto the paper. Quite often by the time I look up from the sketch pad, the figure has changed position or disappeared altogether.

A standing figure will often change from one position to another as he shifts his weight from one foot to the other. In doing so he may revert to the same positions several times and so I start several sketches of the same figure.

Once I have started to draw a figure in a certain position I don't alter it when he moves, I simply start another drawing. Then I am ready to move my drawing tool quickly from one drawing to the next as soon as the subject reverts to his original position. My sketch can end up looking as if I have been drawing a crowd!

An important part of making a figure look 'right' no matter how brief the sketch may be, is to make sure that the head is in line with the foot that bears the weight.

Try it yourself in front of a mirror. As soon as you shift your weight from one foot to the other the whole body and head moves over with it. This in turn can alter the angle of the hips, shoulders, etc.

Repetitive jobs such as unloading boxes of fish on the quayside mean a repetition of the positions of the men who are working. This is ideal from the artist's point of view.

Watercolour and gouache:

Mediterranean Boats

This painting was made from a series of pencil sketches and from memory. Mediterranean thoughts of course, evoke impressions of sunlight, flickers of intense light dancing over the buildings and boats, strong deep blue sky and water, in total contrast to the fishing boats at Rye.

Looking at the painting now, I am interested to review my approach. Although not aware of it at the time, I think it was something of an experiment in that I started it with a wash of blue watercolour all over the paper. My interest now is that we normally think of blue as a cold colour, but using it here as an underpainting has served to accentuate the effect of flickering lights. These lights were produced by dragging opaque thick gouache quickly over the rough surface of a heavy watercolour paper. The sparkle of the light is also intensified by contrasting it against flat areas of the transparent wash of blue.

The distinctive shapes of the prows of these boats overlap and interlock to make a pattern as they face towards each other. Notice that the first wash of blue accounts for a great deal of the painting.

Pastel:

Fishing Smacks, Rye

These old trading smacks at Rye, Sussex, are a type of fishing boat rarely seen nowadays. They are painted in pastel on light pink Ingres paper. The delicate colour of the paper permeates the painting and bestows a gentle warmth.

This delicate background has influenced my choice of colour, which I have confined to soft subtle colours, and the dark tones in the painting are very limited. There is a slight mistiness about the light, and the sky is kept pale. I have used both a warm and a cool white and also a little very pale (tint 0) olive green to convey the quality of light.

The water relies very much on the pink of the paper and here I have used very little pastel. This simplicity of treatment is amplified with a few simply expressed reflections.

The fishing boats were drawn with red Conté pastel pencil which is clearly visible on the masts. Red-roofed buildings in the distance are kept subdued by applying a warm grey (red-grey tint 4) pastel rather than a brighter red which would have jumped forward too much in the painting. Touches of orangy brown, ginger and pale cinnamon colour are powerful enough when surrounded by soft subtle background colours.

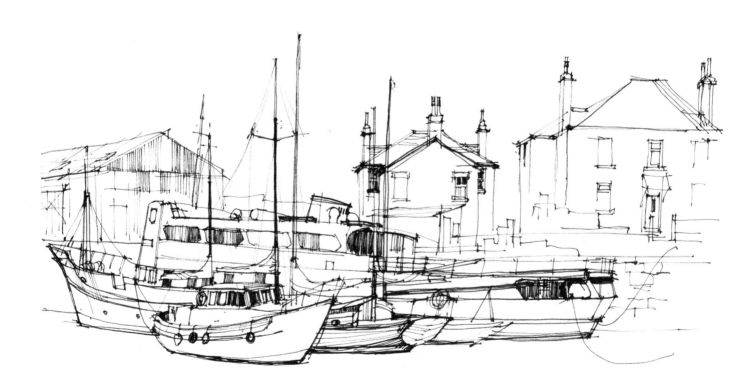

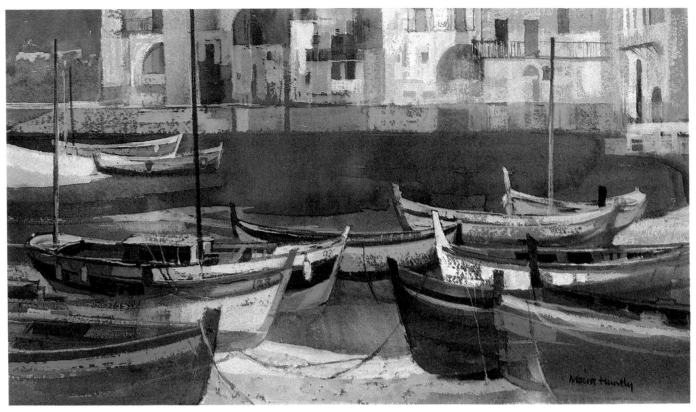

Mediterranean Boats, watercolour and gouache, $8\frac{1}{4} \times 14\frac{1}{2}$ in

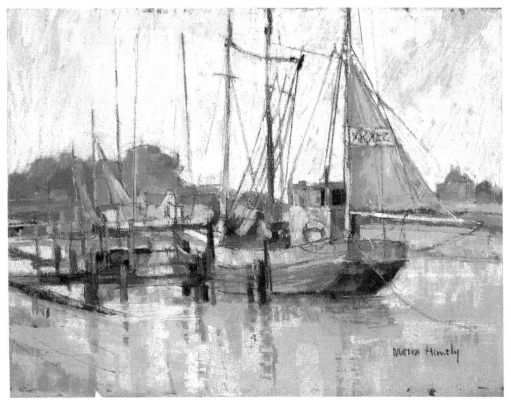

Fishing Smacks, Rye, pastel, $10\frac{1}{2} \times 14$ in

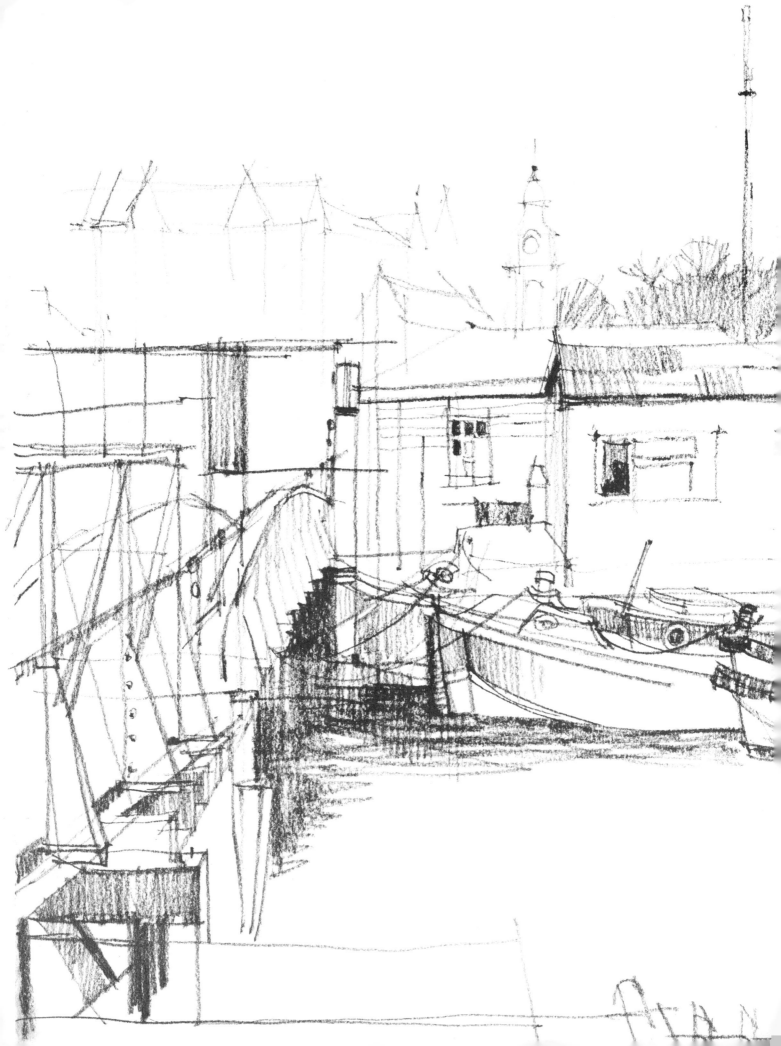

Chapter 3
INLAND AND RIVER BOATS

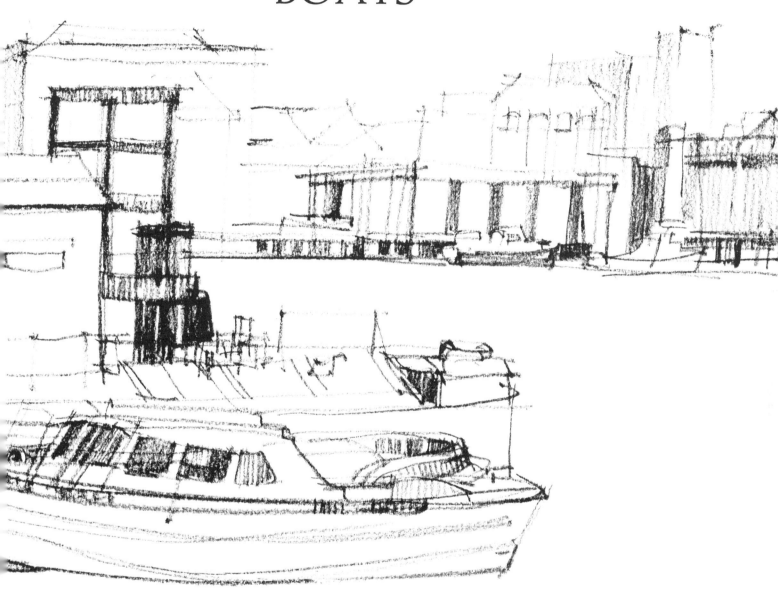

Any stretch of inland water will attract those who like to 'mess about in boats'. In Britain and many parts of Europe canals cut their waterways across the country, opening up new vistas. The unknown heart of a city when viewed from a canal offers interesting new discoveries — a separate world of activity within the city.

Large rivers carry craft upstream for many miles and in these calmer waters it is easier to draw and paint boats. Perhaps the excitement of the salt tang on the wind that has blown in across the ocean, and the persistent cry of the gulls overhead are missing, but there is always the fascination of water.

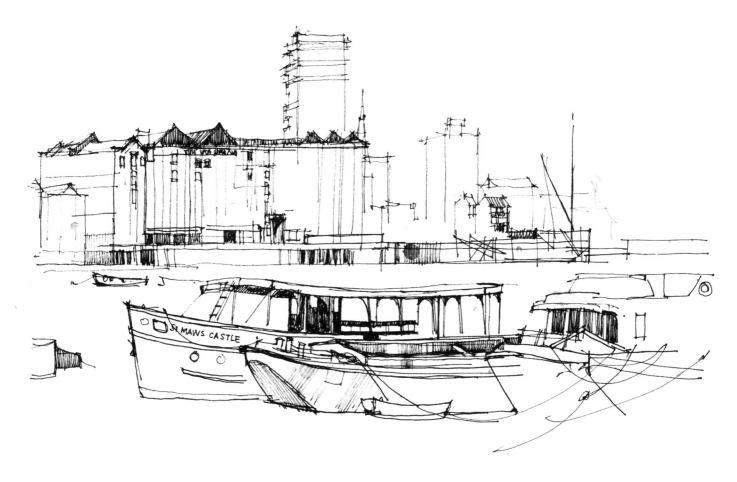

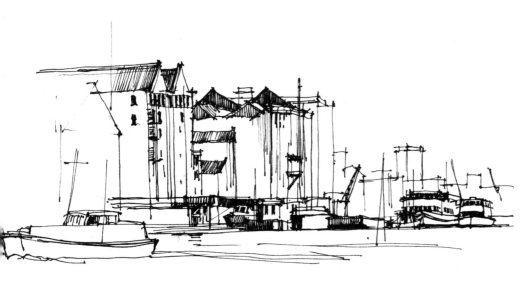

Cherry Garden Pier is within the tidal reaches of the River Thames at Rotherhithe, south-east London, where one can still smell the tang of the sea and hear the call of gulls, and at the same time contemplate the combination of boats and buildings.

I have used this sketch as a study for the painting opposite. Looking at the drawing now, I see a number of possibilities that I could have considered when I came to paint from it. I like the large empty expanse of foreground water, and the narrow strip beyond the boats. This area of emptiness is a reversal of the busy shape of the buildings and pier. The two shapes seem to fit together like two big jigsaw pieces. The small amount of detail at the bottom of the painting catches the eye and leads across the walkway into the mass of buildings. The skyline has interesting rectangular shapes and the single mast is effective in cutting across the skyline.

Fibre-tip pen and gouache:

Cherry Garden Pier, Thames

As the painting of Cherry Garden Pier developed, some foreground fencing was incorporated into the composition from another sketch. The painting is concerned very much with the pattern of the light water and the structural elements that frame it. The squares and rectangles of light so formed are repeated throughout the painting on the sheds and in the distant buildings.

The river scene is painted in gouache, the opacity of this medium enables the paint to be brushed on with positive flat strokes in keeping with the rectangular pattern of the painting. The foreground fence and the boats are kept in a low tonal value to emphasise the light pattern of the water and the buildings. The boats in the foreground are also muted with cool mauve greys to contrast with the lighter bright colours of the sheds and barge.

Big rivers are busy places and here on the Thames can be found long flat jetties and long flat barges, pleasure boats bedecked with flags and full of colourful people, and a constant flow of traffic up and down river.

My sketches were all made in the vicinity of Cherry Garden Pier, on a rainy day. My fibre-tip pen was not waterproof and the spatter of rain drops soon spread into purplish spots. I hastily took shelter before the whole drawing dissolved.

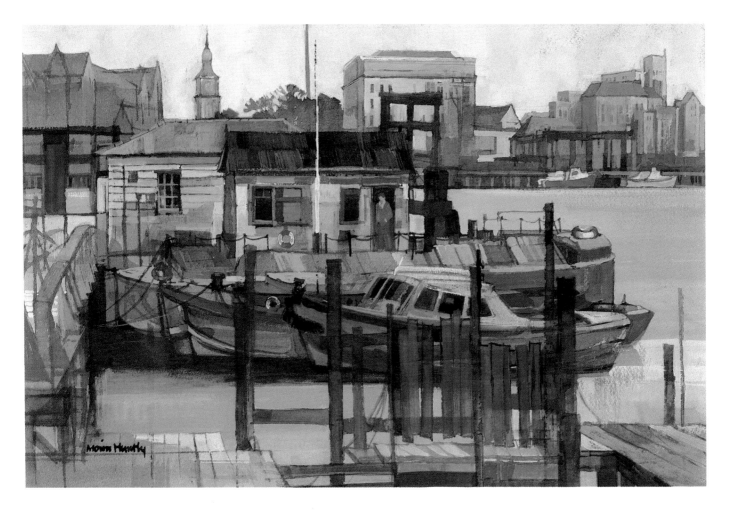

Cherry Garden Pier, Thames, watercolour and gouache, 13 × 18 in

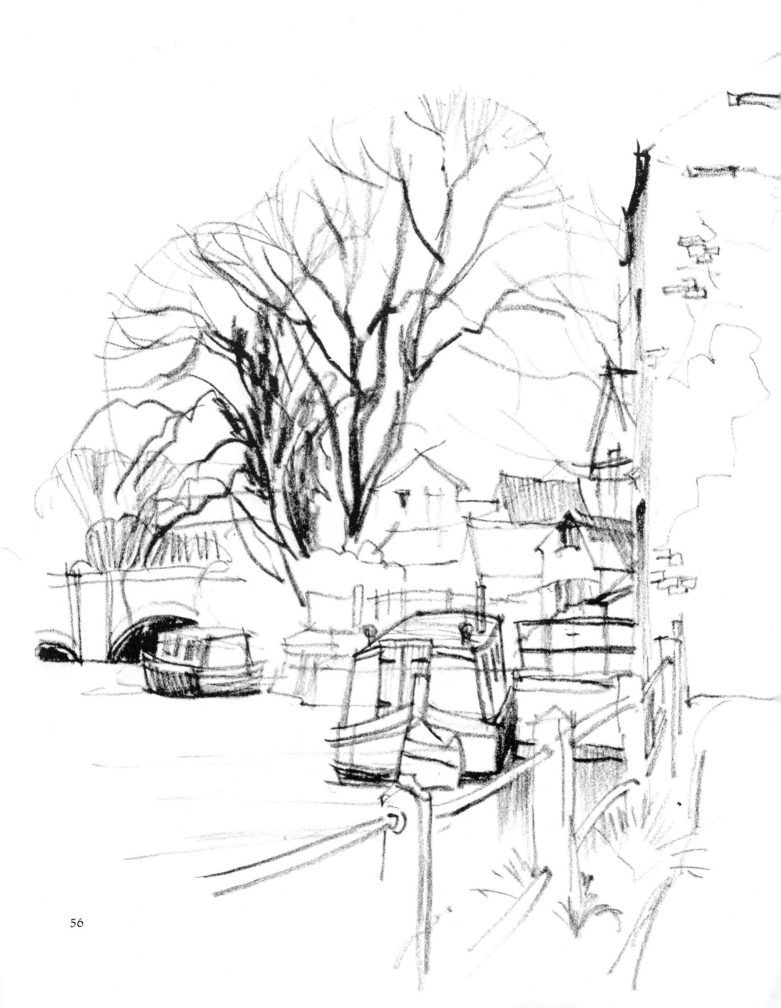

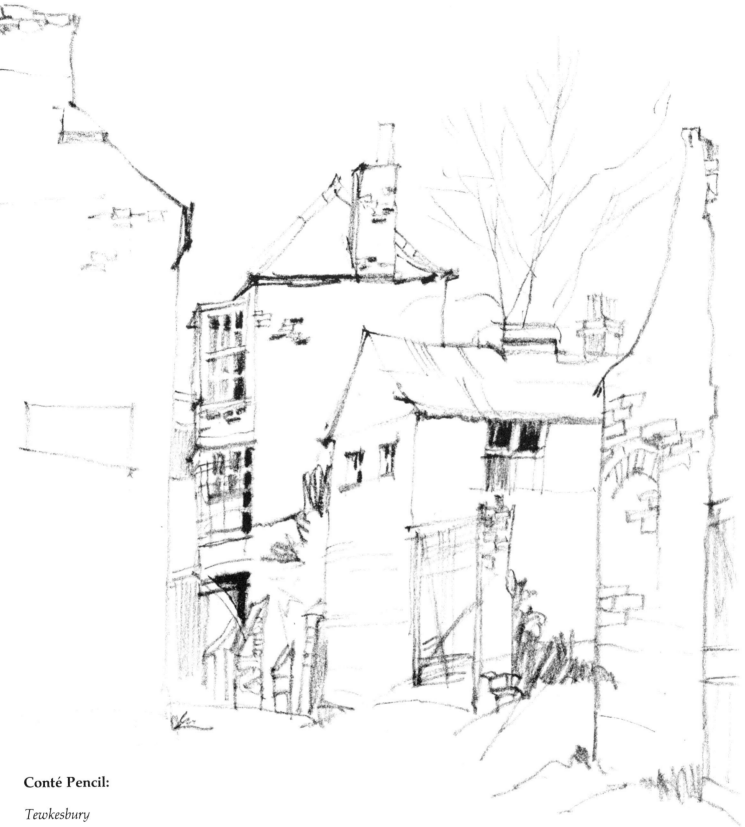

Conté Pencil:

Tewkesbury

Very often the work of marine and of landscape painters overlap. Here is an example with buildings appearing prominently in the drawing and the boats are almost incidental. I was attracted to the big central building flanked by the river on one side and buildings on the other side.

Colour Sketches

Painting boats may be less dramatic inland than at sea; inland they mingle intimately with the landscape, or perhaps add interest to a townscape.

My sketches of the river at Tewkesbury were 'on the spot' records of colour and atmosphere. I wanted to record the jumble of colour: oranges, browns, blues, greens, and the contrast of white.

It was fascinating to observe that the colour of the boats and the colour of the buildings were indistinguishable, especially so in the reflections.

This is a working drawing and I have loosely indicated the colours in the sketch as a reminder to me when I

eventually paint from it. For the same reason, I did not bother to complete the painting of the bank on the near side, nor was I concerned with the quality of edges.

It was the traditional practice to stain or tint a pencil drawing with watercolour washes. These transparent washes allow the drawing to show through the colour and in this case it is the drawing that is more important than the painting. The painting would not stand on its own without the line.

The sketch was made on cartridge paper out of my sketch pad and the weather was sunny. The washes sank

immediately into the paper and dried instantly – a watercolourist's nightmare. But in this case the washes provided me with the information I needed and so they are adequate.

The colour sketch shown opposite was made earlier on the same day, but the sky was not so blue, thus affecting the colour of the water. All the colours are subtle and I liked the pattern of strong darks made by the doors and windows and part of the boats. I was quite pleased with the effectiveness of using just a few colours to help establish my impression of the scene.

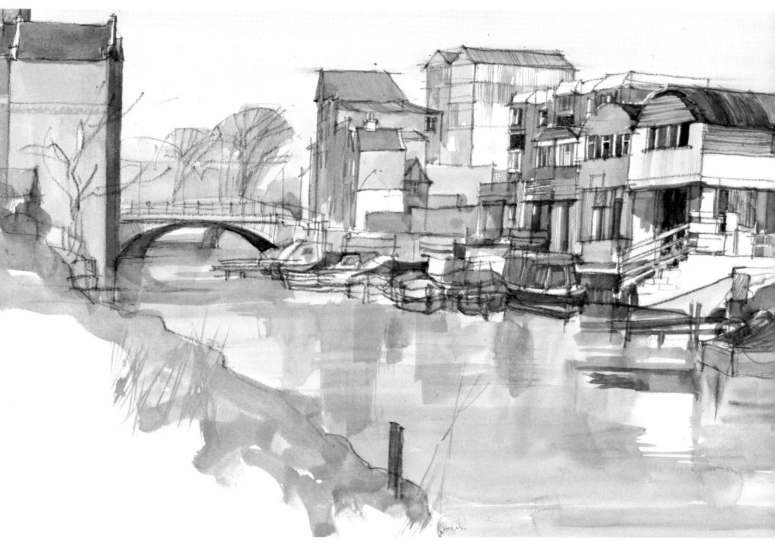

River Avon, Tewkesbury, Conté and wash, 11 × 16½ in

Tewkesbury, with Abbey Tower, Conté and wash, 15 × 11¾ in

58

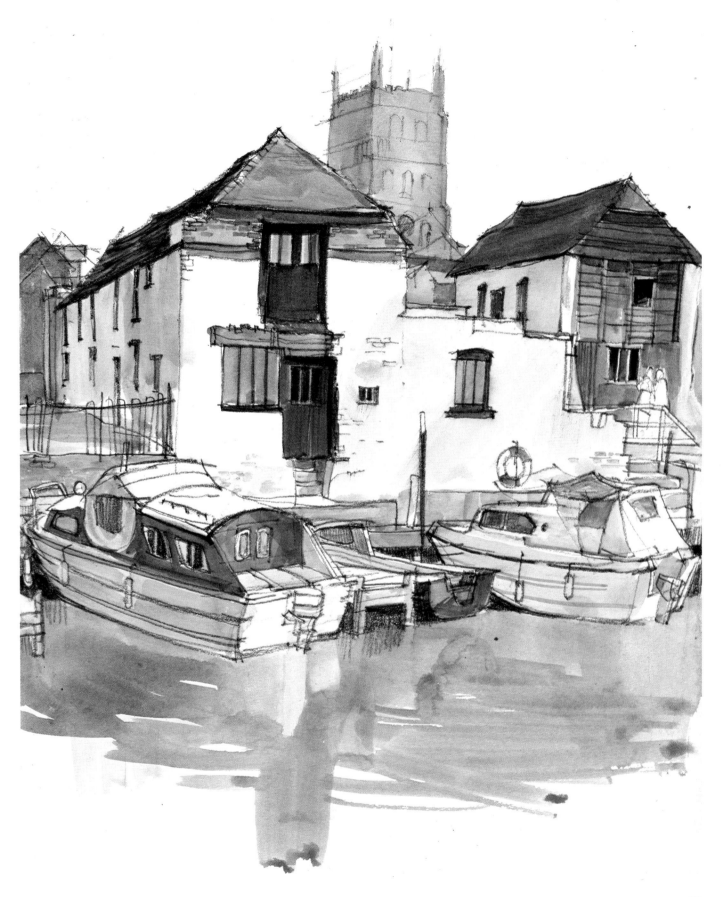

Drawing and oils:

Reflections, Gas Street Basin,

As you can see from the sketch these industrial canalside buildings in the centre of Birmingham were intriguing to draw. The roof of one building was very unusual, it sloped steeply and unevenly, and the gable end was also uneven. The day was dull and damp, and the water in the canal was so still that there were no ripples to disturb the almost perfect reflections. However, there are subtle

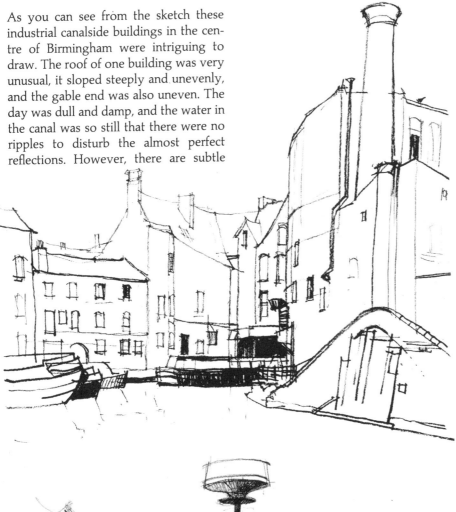

differences to be observed between reflection and reality. In painting the mirror image the tones were carefully judged, light areas were painted slightly darker in tone in the reflection and dark areas were painted slightly lighter in tone in the reflection. This makes tone values in the water less contrasty and gives the reality some sharpness by comparison. I observed that edge values in the water were gently blurred. Some of the Narrow Boats (canal barges) moored in the basin were traditionally decorated with brilliantly coloured patterns and paintings, and others were black and white with red lettering and paintwork. This quiet scene was in the heart of a bustling city, beyond the buildings lay a world of noise, commerce and traffic jams.

My other drawing is of a heavily laden working barge, the 'Chaceley' from Hull, which arrived at Gloucester docks, and I took the opportunity to make a drawing, but it proved to be a difficult subject.

The problem was that of proximity, my sketching position was too close to the barge, and I had to make adjustments. Ideally, I would like to have been further away from it so that I could view the barge overall. Unfortunately I was already at the end of the quay and a step backwards would have been disastrous.

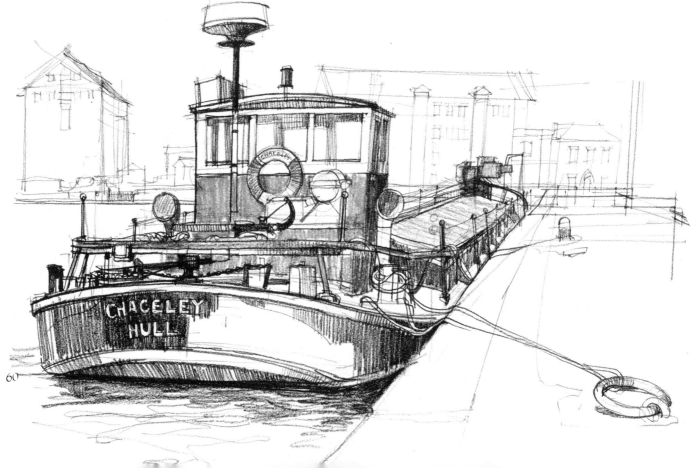

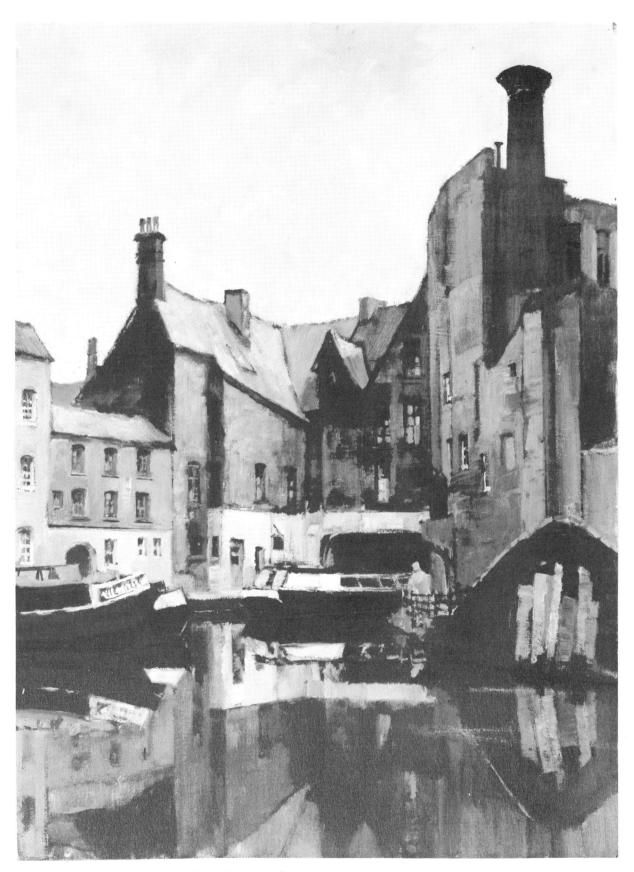

Reflections: Gas Street Basin, Birmingham, oils, 15 × 11¼ in

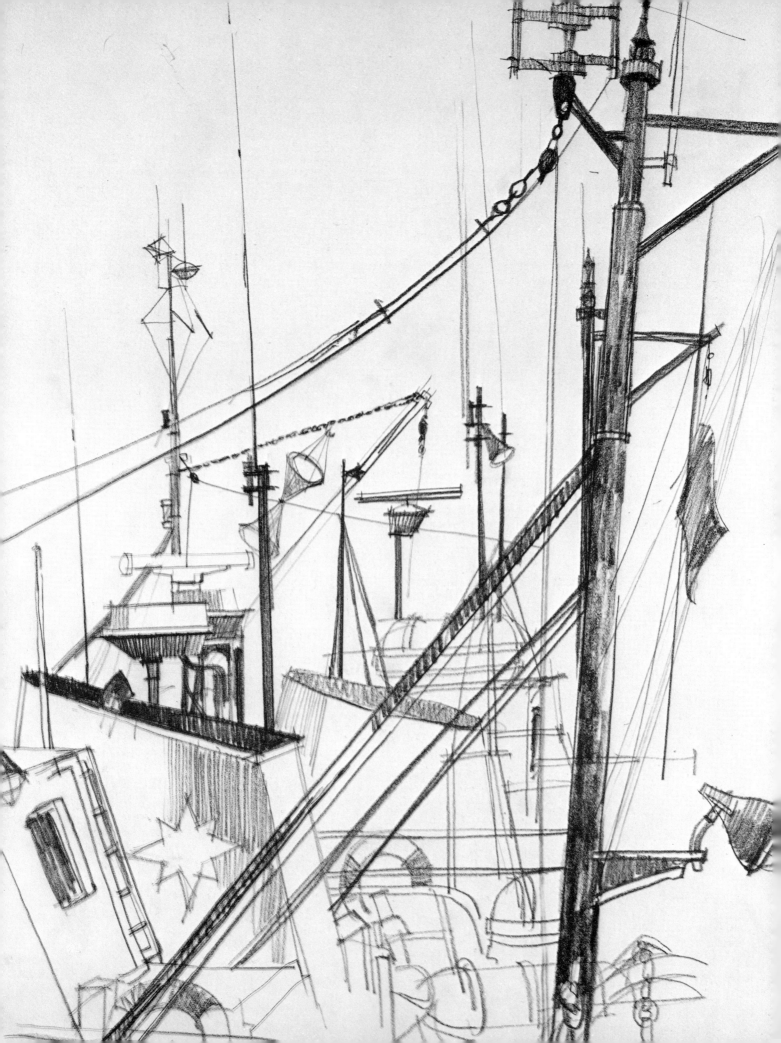

Chapter 4
DETAILS

During the process of drawing a subject it often happens that we become engrossed in the detail to the detriment of the overall conception. There is a danger that we miss the general relationships because we have become too much involved with a small area. This area can easily become isolated in the composition and be a distraction.

In this chapter I deliberately concentrate on drawing details for two reasons. One purpose of studying detail is in order to provide a fund of reference and knowledge of a subject. My second purpose in studying detail is to search for abstract elements within the form, which can stimulate new ideas in composition. In fact, it often happens that, as I am making a working drawing of a detail, I become more interested in the abstract elements of shape and pattern, colour and texture. Drawing or painting a distant subject, which may not be clearly visible, can be more convincing if you have prior knowledge of the details; a loosely brushed in hint of detail should leave the viewer satisfied that it is correct.

Details can sometimes be used to good effect in the foreground of a seascape or riverscape. Generally speaking, seascapes tend to be horizontal in composition, and it can be interesting to break this up by viewing the seascape through some foreground detail. In this way the detail provides a framework that is a deliberately considered part of the composition.

Drawing the whole boat is rewarding, looking at the parts that make the whole is also rewarding.

Individual items such as machinery on deck, linear pattern of masts and rigging, propellers and rudders, ropes, chains, anchors and so on, all have their own character. The colour and texture of paintwork ravaged by sea, sun and barnacles are worthy of study. This leads us to search for ways to achieve textural effects in paint, perhaps by experimenting with mixed media, or by varying our method of applying paint.

It is interesting to examine natural objects such as rocks, pebbles, shells and seaweed, and note the colours. These colours can be utilised in a future painting.

The drawing on the opposite page, *Masts at Kinlochbervie*, developed from drawing one mast for information. This stimulated my interest and I continued to record the pattern of mast shapes against the sky. I realised that the scene contained lots of detail, lamps, lifebelt, chains, conical details suspended between the masts. I emphasised the masts by drawing with Conté pastel pencil pressed heavily onto the paper, and I subdued the details by drawing again with a Conté pencil, but with less pressure.

Drawing, watercolour and gouache:

On board 'Dunane'

For the pen and ink drawing, the pen was an ordinary dip pen and I used black waterproof ink. The drawing was done fairly quickly – it is sketchy, light and freely drawn – but I did concentrate on accuracy of form. The curvature of the boat and its construction are as precise as possible. The drawing was made as information for future painting.

The view of the pointed stern of this smaller fishing boat was drawn with a fibre-tip pen giving a thicker bolder line.

The winding gear on board the fishing vessel, the 'Dunane', opposite was painted in watercolour with gouache added to areas of light tone. After the first loose washes were dry on the paper, the subject was 'drawn' in burnt sienna, with a very old stick of solid watercolour (no longer available). The colour was appropriate to the ropes and netting and a textural effect was achieved on the rough surface of the watercolour paper.

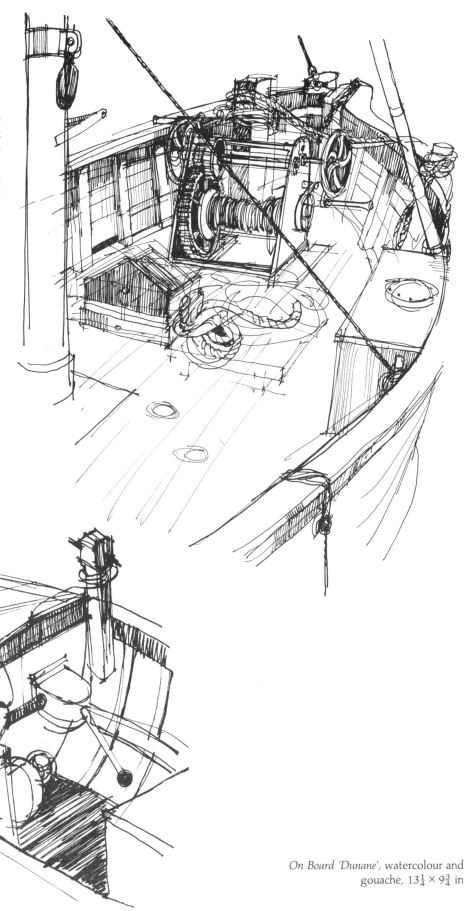

On Board 'Dunane', watercolour and gouache, $13\frac{1}{4} \times 9\frac{3}{4}$ in

64

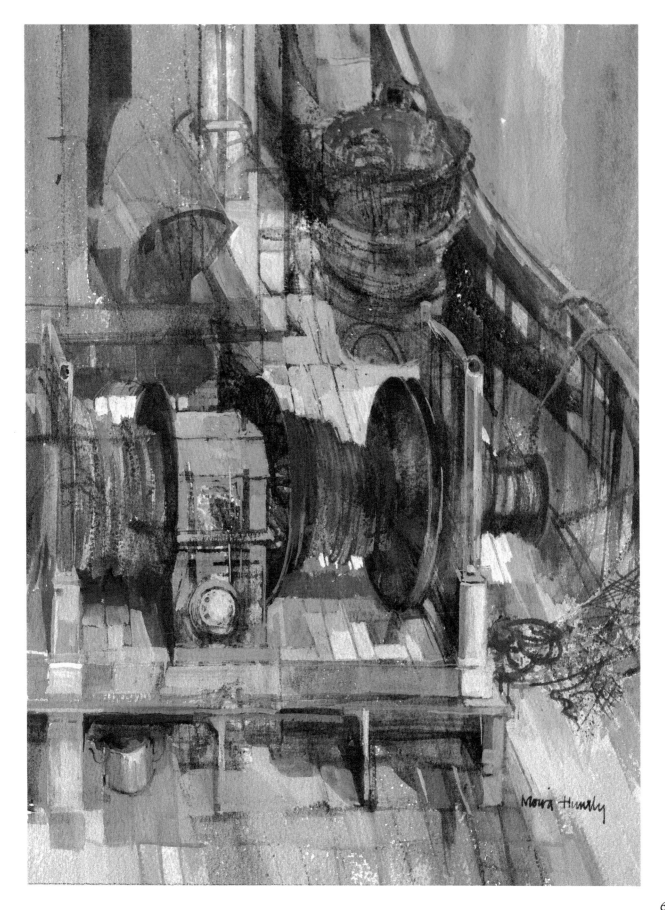

Moira Huntly

Ink and watercolour

In my line and wash sketch made at Gloucester docks I concentrated on part of the barge, the stern end, so that I could focus on a few details. These details form important elements in the overall composition.

The bollard on the quayside also makes an important contribution, and I have deliberately kept it simple in treatment without elaborating the washes. Its main purpose is to cut across the hull of the barge to produce two dark rectangular shapes. These darks are made with strong washes of blue-black watercolour to make them stand out against the paler washes elsewhere. These dark washes also help to emphasise the white bands on the barge so that the dark blue and the clear white provide strong contrasting elements cutting through the composition. The shape of the bollard is echoed by the mooring cleat on the stern of the barge, and the lamp posts and handrail introduce some vertical elements in the sketches.

I deliberately made the sketch to a square shape within which I tried to produce a balance of interesting shapes and lines.

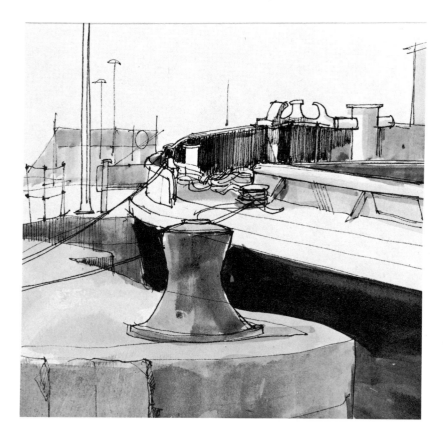

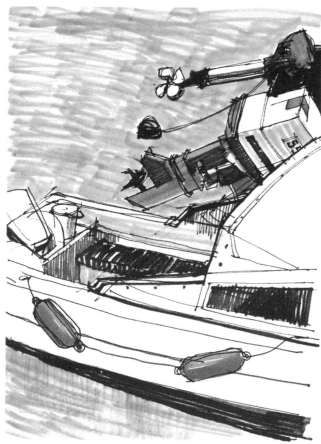

Outboard engines, propellers, rudders and keels are all of visual interest. Whilst looking at a line-up of boats in the harbour at low tide, I observed that each rudder was of a different type. Some were attached to the transoms and some to the keel. Each rudder was an interesting shape in itself and as I made my drawing it became apparent that the white of the paper between the dark interlocking shapes of the rudders and boats was equally of interest. The impact of these shapes was enhanced by drawing them with strong thick line work. Elsewhere some of the drawing is made with a thin almost tentative explorative line. I used a variety of fibre-tipped pens.

The effectiveness of the shapes relies very much on the selective use of tone, making a design of strong darks and lights. For the tone I used broader felt-tip pens, sometimes applying ink as solid areas of tone and sometimes with openly spaced lines.

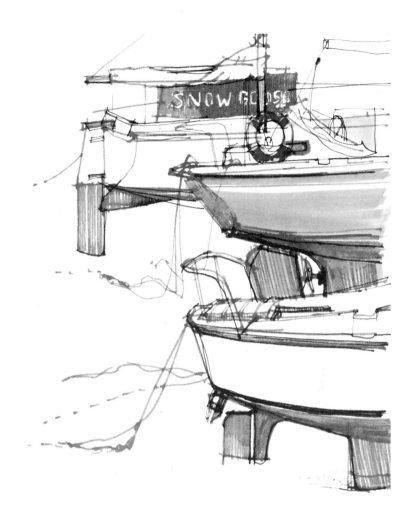

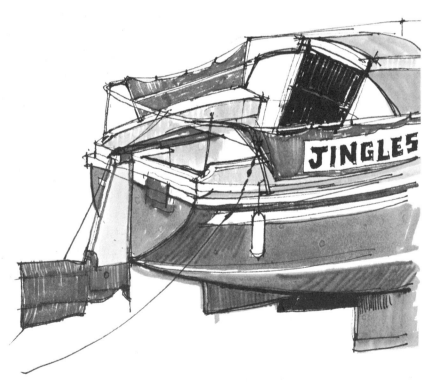

I used mostly pens with different shades of blue ink, which combines with the white areas of paper to emphasise the nautical flavour of the sketch. Here and there I introduced a few touches of red to give importance to some of the details such as the lifebelt or the propeller.

Step-by-step in oils:

Floats

This painting is concerned with colour and repetitive shapes. The boat was bleached by sun and salt and moored high on the beach at Abersoch, North Wales, seemingly abandoned. I was excited by the contrast of the brightly coloured plastic floats and buoys spilling down the bank. The anchors and coils of rope make curved shapes that repeat the curve of the hull. Some of the floats are rounded and some egg shaped, a shape repeated by the blades of the propeller.

Materials

Brushes: no. 6 short flat hog hair
no. 1 long flat hog hair
no. 9 flat ox hair
no. 5 filbert hog hair
Support: oil board
Palette: viridian, cadmium orange, titanium white, alizarin crimson, burnt umber, raw umber, prussian blue
Medium: turpentine substitute

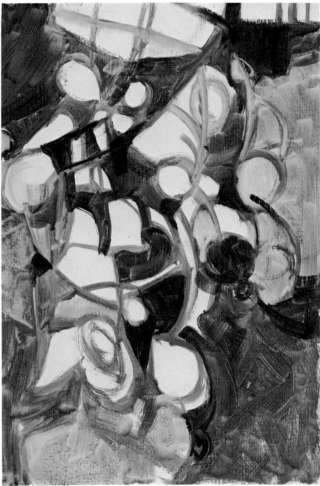

Stage 1 The arrangement of circular shapes spreading down from under the hull was painted with the large brush and viridian thinned with turpentine substitute.

Stage 2 The tonal pattern was taken a stage further with darker green obtained by using less turpentine and adding some raw umber to the viridian, further darks were added with burnt umber and the no. 5 and 6 brushes. Counterchanges of dark against light tone and vice versa were incorporated into the painting.

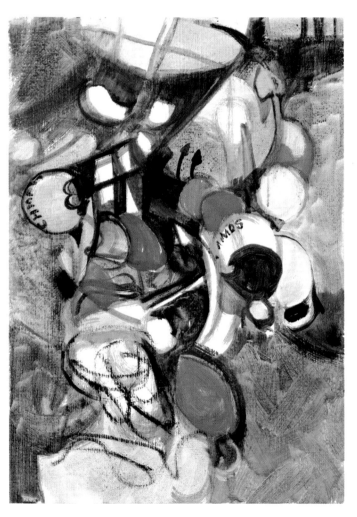

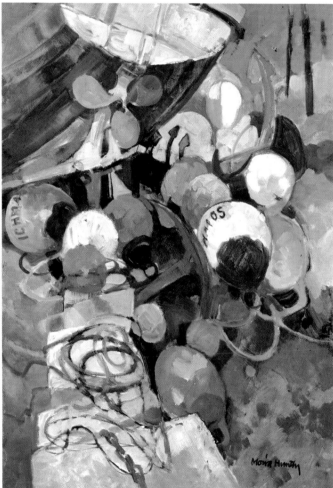

Stage 3 I established the colour composition by distributing the warm colours amongst the overwhelmingly green underpainting. Red and green colours react strongly to each other and are exciting. A small amount of red in a 'sea' of green is very dominant and so it was necessary to give careful thought to the placing of these warm colours in the composition. Colour was still being applied thinly at this stage, and touches of blue and more detail were added with the small brush.

Stage 4 (final) Thick paint was now applied without any turpentine, many adjustments being made as the painting developed. Some areas such as the sky area of the top right background were simplified.

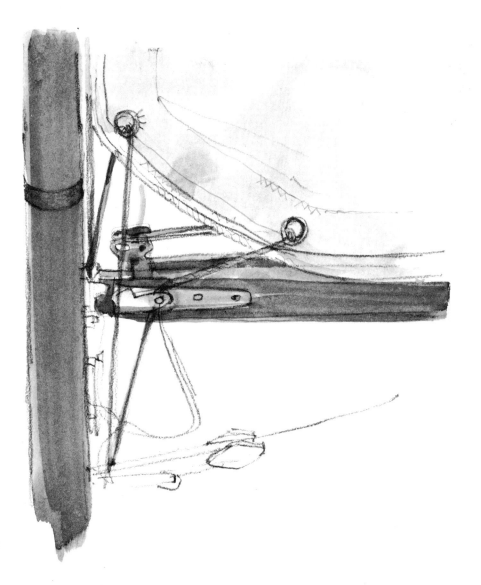

Sketchbook drawings

The detailed drawing of the mast and boom and part of the foot of the mainsail was made with a Conté pastel pencil and loose watercolour washes. The patterns made by the ropes were intriguing and the sketch became an inspiration for the painting overleaf. It was the starting point, and in combination with it, I used the sketch (opposite) of dinghies and their colourful covers. Although it isn't really a detail sketch I have included it here to demonstrate the use of a combination of sketches to make a painting. The mast and boom put in the foreground provide the main interest and are supported by the abstract shapes and colours of the dinghy covers.

Seagulls
Seagulls are an inseparable part of marine subjects, they add a nice touch of life as a foil to the formality of boat structures.

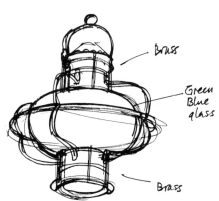

Brass

Green
Blue
glass

Brass

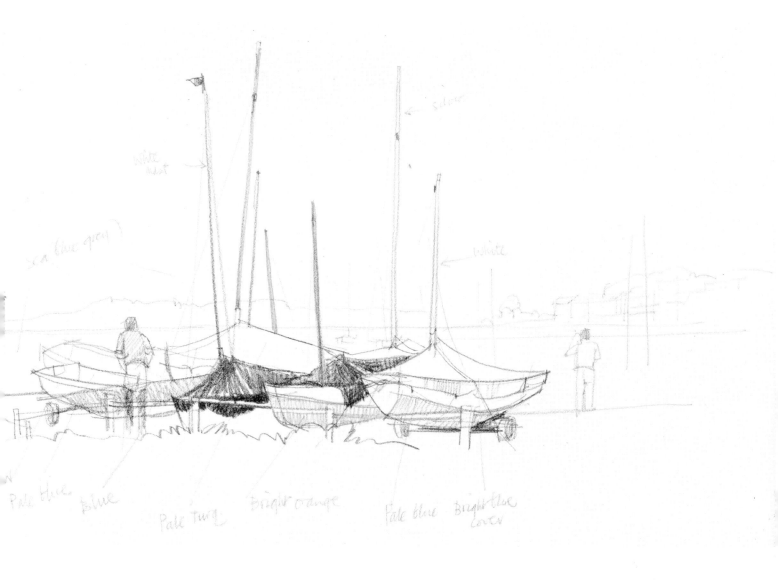

Pastel:

Dinghies at Mudeford

In the painting of *Dinghies at Mudeford* overleaf, the placing of the mast and boom was considered first. These make strong vertical and horizontal divisions in the picture area and my next consideration was to place objects such as the left-hand lifebelt at a focal point. The dinghy covers made a strong pattern of flat abstract shapes, their curves echoed by the ropes that hung idly from the boats.

Colours noted at the time of making the original sketch, feature strongly in

the painting and are repeated in a muted version on larger areas of the composition.

I have grouped together most of the brightest colours and extreme tonal contrasts in small individual shapes, and the impact of this concentration of these strong pattern elements in the painting is balanced by the powerful straight lines of masts and boom.

Blue and orange are opposite to each other on the colour circle and small areas

of opposite colours when used in proximity can add a certain vibrancy to a painting. Large areas of opposite colours in proximity can be confusing to the eye, but unequal areas can intensify the colour used in the smaller amount. For example, the orange colours in this painting are surrounded by blues and 'sing out'. They are further emphasised by being viewed under a large area of grey sail, which helps to concentrate the vibrancy of the colour.

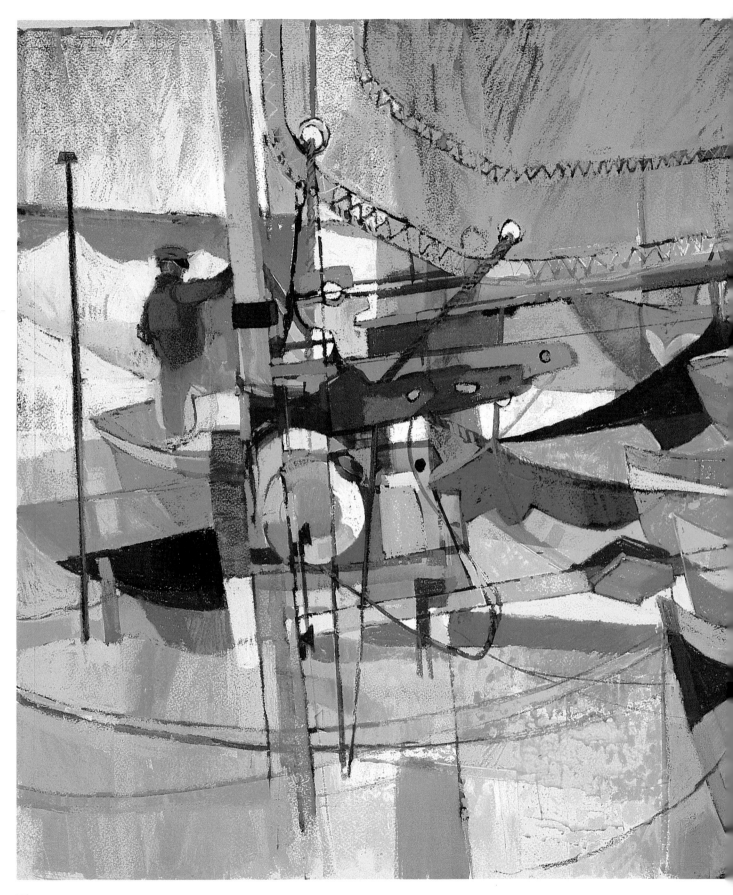

72

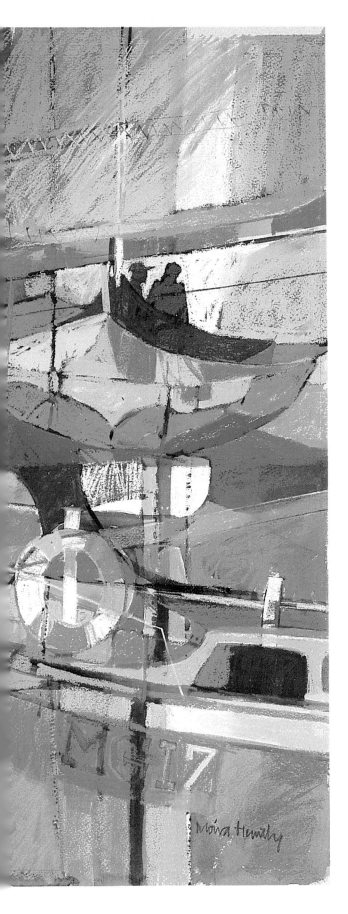

Dinghies at Mudeford, pastel, 18 × 25 in

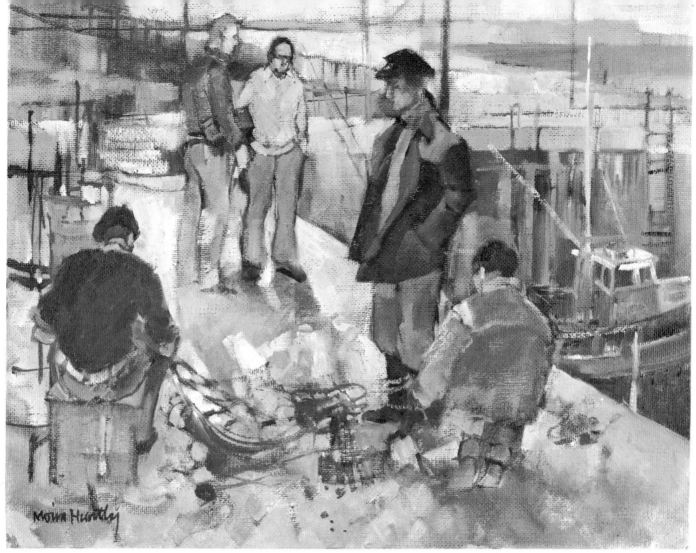

From sketchbook to painting

I like to stroll around a harbour, carrying with me a small sketchbook in which I jot down quick sketches of bits and pieces. They are really done for my own enjoyment, private jottings which, with time, build up to a library of pieces of information which may provide useful details for future paintings. More importantly, they recall for me moments of time, things that I have seen, all of them contributing to a build-up of knowledge and love of nautical subjects.

I like to make these drawings fairly quickly with loose free line work, but without sacrificing accuracy. Fibre-tip pens are ideal for this purpose, and by changing the pressure I can vary the line quality and thickness, so that I can emphasise the parts that especially interest me.

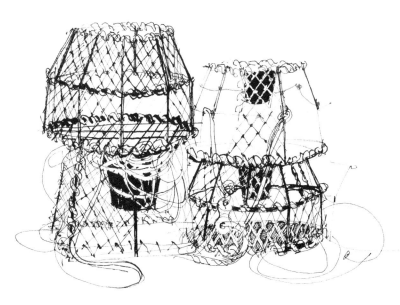

Lobster pots The sketch selects a few parts rendered in solid black to show the nature of the mesh that makes up the basket. Elsewhere the line work is quick and sketchy aiming for an impression of the light mesh, rather than a laborious attempt to reproduce accurately every part of the pot.

Anchor I like the angle at which this large anchor was leaning against the handrail. Notice the explorative nature of the line, seeking the accuracy of the curved parts. Shading is used selectively, seen in the strong shapes of the anchor flukes and echoed in the ring at the top of the anchor. The effect is better than it would be if all parts of the drawing were shaded.

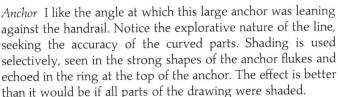

Fishermen The sketch of fishermen pulling in the salmon net was also made at Mudeford, unfortunately the activities were over quickly, three large salmon having been successfully netted. I would like to have made further sketches, especially of the men with the brightly coloured fishermen's aprons.

Mending nets The quayside oil painting was composed in the studio from several sketches. I enjoy making composite paintings put together by using more than one sketch, a collection of informative sketches can be used ad infinitum for many different compositions on the same theme.

Anchor and lobster pots This drawing was made from a low level, looking along the surface of the ground towards the anchor. I liked the silhouetted effect of the ring and the dark parts of the anchor. The lobster pots are indicated as background incidents and the line work is a spontaneous thin and sketchy line.

75

Drawing on tinted paper

Sketching on tinted paper is good on hot sunny days when there is too much glare off a white paper. For the sketch on the opposite page I used a combination of broad felt-tip pens in three different colours, white Conté pastel pencil and a thinner black fibre-tip pen for the rigging.

This combination of media provides a versatile range of colour and tone within the sketch. Counterchanges such as the light rigging and ropes against the darker background, and the dark rigging against the light sky can be indicated more easily on a tinted paper.

I refer to Turner many times in this book for there is much to be learned from his way of working. Some of his sketchbooks were of blue paper and he used a combination of brown washes and line work, and white gouache to make very effective tonal sketches.

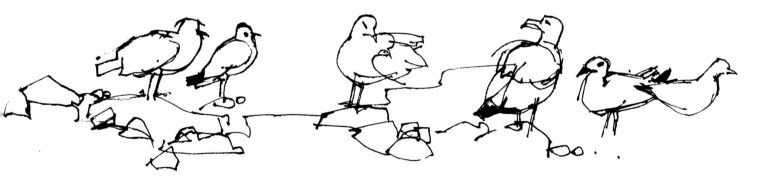

Masts, felt-tip pen and pastel pencil,
$17 \times 9\frac{1}{2}$ in

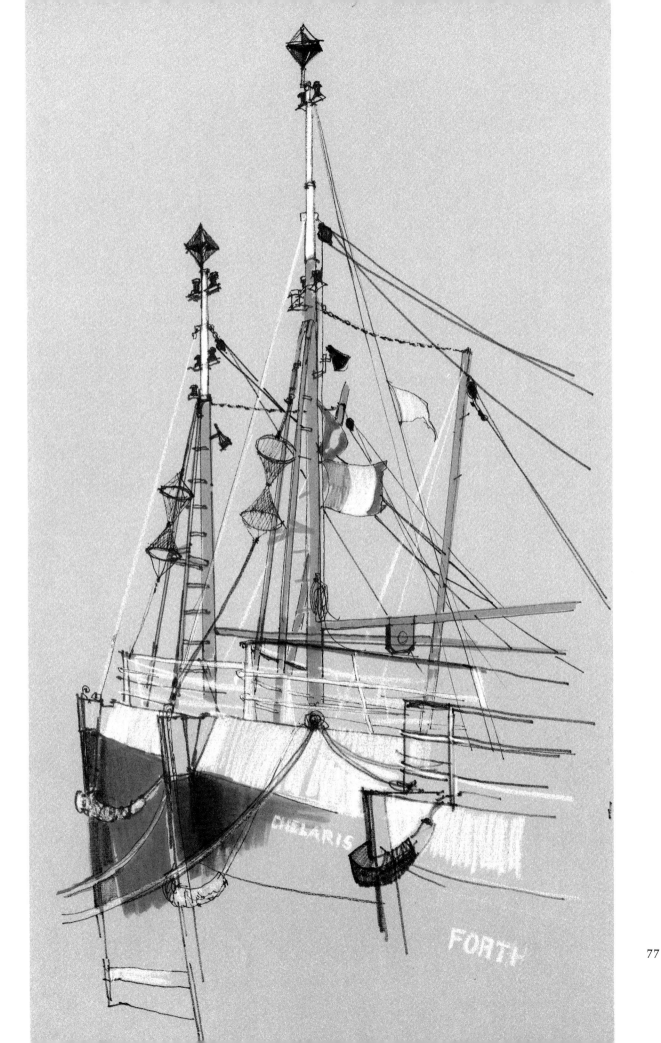

CHELARIS

FORTH

77

spray higher
than lighthouse

Pal

dk b

Chapter 5

SAIL AND SEA

Rugged coastlines and shifting sands bear witness to the fearful power of the sea, which relentlessly pounds the land when weather is rough and gently laps against the shore on calm days, an element never to be ignored. The wind is rarely absent and brings the satisfactory smell of ozone. My sketch was made during a painting trip along the coast of Scotland with another painter in late December. The day started with pouring rain and it was cold; we travelled some distance fighting lethargy and, turning down a minor road, we arrived at a small beach. Suddenly we were faced with a stormy sea immediately before us. Masses of black rock stood in boiling foam and, beyond them, the sea could be seen, grey and forbidding, with a large swell. Then between the rocks the grey water flooded with huge cascades of spray, blotting out the rocks with a noise of thunder.

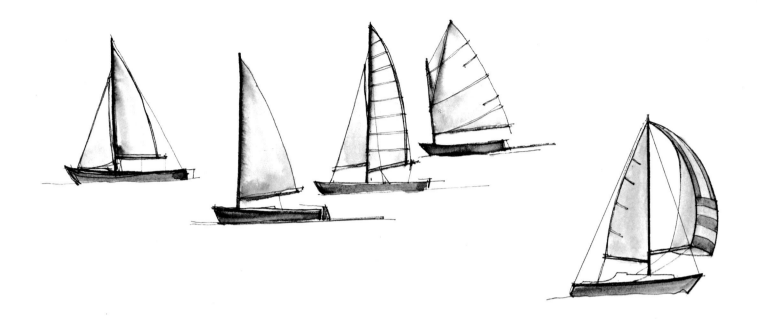

We made numerous quick sketches with spray breaking over us. Lethargy was forgotten, we felt exhilarated, my companion slithered over rocks to get another view and returned wet but enthusiastic. I noted the colours, grey greens, black rock, brown-green seaweed, wet and shiny, and the violent upsurge of white spray. It was impossible to paint, but the memory is clear to paint on another day.

Later that day I saw a lone fishing boat battle to cross the bar at the mouth of a harbour. It was truly a power struggle of man against the elements, man attempting to master the sea with his skill and knowledge and with centuries of experience in boat construction behind him.

With sail, man makes use of the elements; sailing boats often have slender, graceful lines to cut through the water, but at the same time they must have strength to withstand the pressures of the wind and sea. The earliest sails were made of leather, and then the Egyptians made sailcloth from flax. The Vikings used wool criss-crossed with rope to give strength, but flax predominated. Later on, schooners and yachts used cotton for sails, but cotton could shrink and, when wet, weighed more heavily than flax. Nowadays sails are made of man-made fibre, terylene or

dacron, which is stronger and lighter than flax. Sails can be very colourful, especially the big spinnaker sails, and they make good painting subjects.

The diagrams show a variety of small boat sail shapes and of different mast positions, relative to the length of the boat. Look for these individual differences in order to capture the character of the boat you are drawing or painting.

Painting from a rapidly moving boat is almost impossible. Turner, who was a frequent traveller by sea, made many quick sketches and colour notes to work from in the studio. Today, we have the additional aid of the camera; photographs can be a useful extra reference to back up the sketches.

Drawing a moving boat even from the shore is difficult, and drawing sailing boats is rather like drawing moving figures. My technique is to have several sketches developing simultaneously; racing dinghies will repeat the same tacks, heel over round the buoy at similar angles, etc. and I can gradually capture information.

Step-by-step in watercolour and gouache:

Spinnakers

This painting was made in the studio from several sketch notes and photographs. My aim was to capture the feeling of the day, a fresh sea breeze, and movement in sky and water.

Stage 1 The sky and sea were painted freely over the paper with manganese blue, cobalt blue and touches of ultramarine, I used a large brush and left white paper as the sails.

Stage 2 The sailing boats were drawn with a small brush and a mixture of ultramarine blue and indigo. More blue washes were added to the water, deepening in tone at the horizon, an effect which I have often noticed in certain lighting. The quality of light at sea is constantly changing, the sea is not just a flat plane, it has depth as well. Perhaps this is why it does not always reflect the sky colour. On the whole it does, however, and the colour of the sky and sea can often be reflected by the sea onto the hull of a ship.

Stage 1

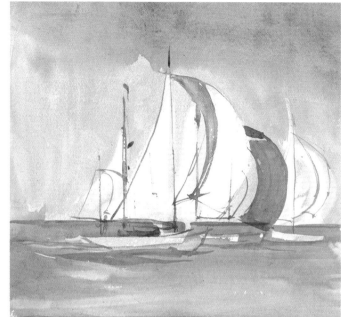

Stage 2

Stage 3 Washes of olive green and a few brush strokes of milky white gouache have been added to parts of the sea, and white gouache, detail and colour have been added to the boats. At this point I found it difficult to judge how far to take the detail without losing the free manner of painting, which I felt gave a feeling of spontaneity and freshness to the subject.

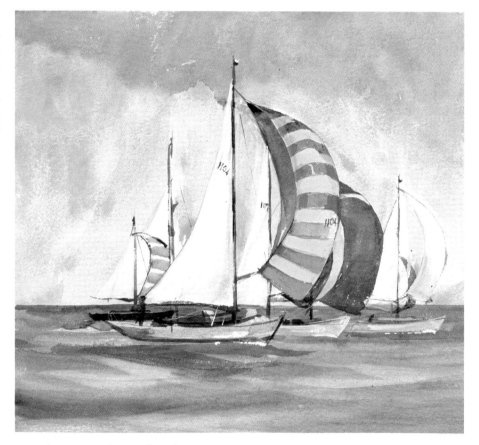

Spinnakers, watercolour, $10\frac{1}{2} \times 9\frac{1}{2}$ in

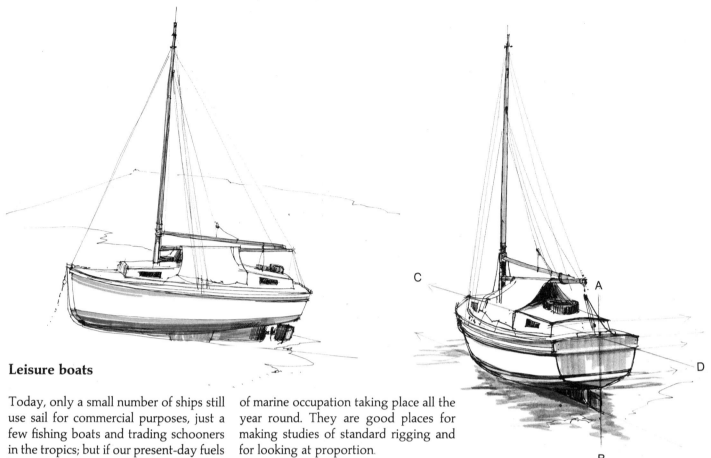

Leisure boats

Today, only a small number of ships still use sail for commercial purposes, just a few fishing boats and trading schooners in the tropics; but if our present-day fuels become scarce, sail will again be of great importance. In fact there are some large sailing ships being developed to compete with power vessels. They will be five-masted bulk carriers, with diesel engines in addition to square rigged remotely controlled sails; all this made possible by today's new technology. It is an exciting concept.

But for most of us, sailing is for sport or leisure and marinas abound all over the world. For the artist, marinas provide a scene of continual activity, there is always something happening, some form of marine occupation taking place all the year round. They are good places for making studies of standard rigging and for looking at proportion.

Yacht proportions

Fig. 1 As a start, I indicate the length of the boat, and then compare it with the height of the mast. I note the position of the mast relative to the ends of the boat, and then I estimate the height of the hull at the bow end and compare this measurement with the length of the boat. It is surprising how many people make this measurement too deep.

Fig. 2 Exactly the same comparisons are made as in Fig. 1. But from this angle it is the height of the transom that is compared with the length of the boat. The centre line through the transom (A–B) demonstrates once again the perspective rule that the nearer half appears to be larger. All the arrowed lines are converging imperceptibly as they travel towards the horizon. (C–D) represents the horizontal line between bow and centre of the transom (horizontal on this particular boat).

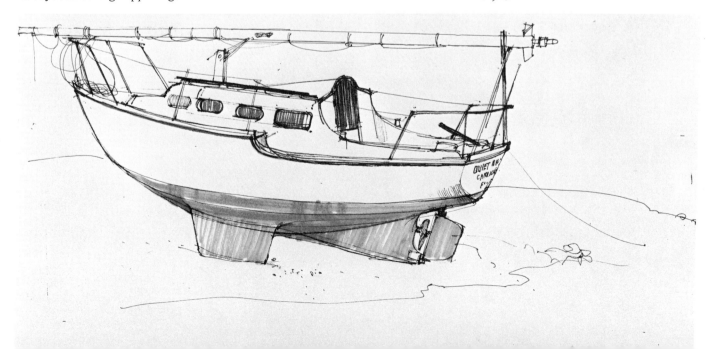

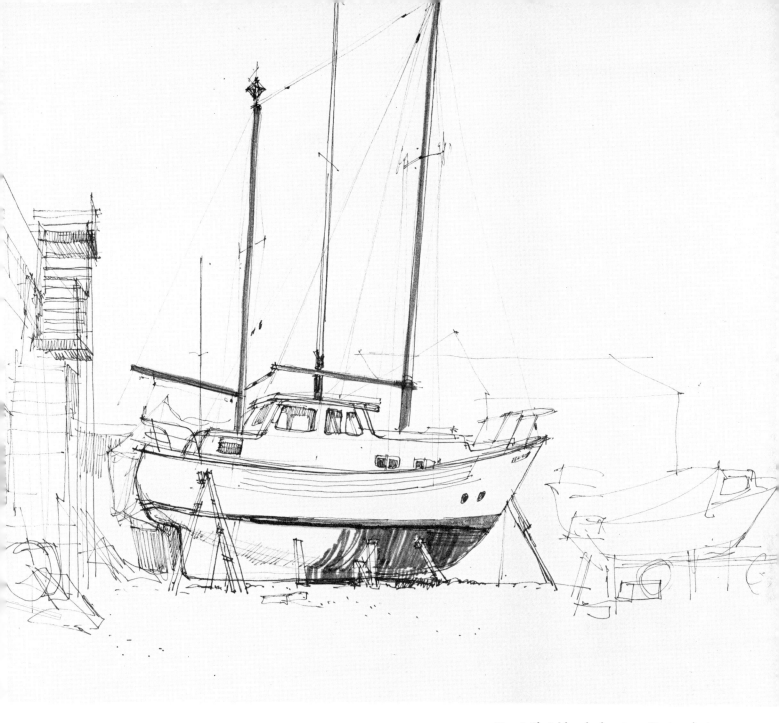

Fig. 4 Sketchbook drawing, *Boatyard at Lymington.*

Fig. 3 This slightly angled view of a similar yacht demonstrates very clearly the comparison between the length of the boat and the height of the mast. The hull is of a different construction and I made more than one height measurement along the hull.

Sea sketches: awareness of colour

The sea has an amazing capacity for changing colour, according to the weather and to the locale. I have seen greeny-brown, steel-cold grey and a beautiful azure, milky green, grey green and deep indigo, in fact all shades of green and blue in the water.

I made a few colour notes of the changes that took place during one summer day. Early in the morning there was a feeling of tranquillity, the sky and sea were almost as light as each other and a soft misty yellow, the horizon barely discernible. Boats waiting to enter the harbour as the tide turned were of a steely grey colour, all one tone and dark against the water. In the afternoon the sea and sky were shades of blue, colour-ful speedboats churned up the calm surface of the water into strips of white foam, all seemed salt and hot sun and feverish activity. In the evening the sky had lightened again to a pale blue-grey and the sea was a darker soft blue-grey which seemed to deepen in tone at the horizon. This may appear so because the lightest part of the sky is at the horizon and so the tonal contrast between sky and sea is at its greatest. The boats were brilliantly lit and vibrant in colour as they were caught in the warm evening sun-shine, very light in tone against the matt backdrop of the sea.

The colour sketch above was made on the spot but further along the Welsh coast on the next day. The cliffs and rocks were surprisingly colourful, rich and dark in tone against the sea, and the waves were coming in, ceaselessly slap-ping their spray up the rocks. I found it mesmerising.

The lighting was quite different in my other sketch opposite. This time, the dark sea and sky emphasise the light pink of the cliffs. The sketch was made with great difficulty because the wind on the top of the cliff was near gale force. My sketchbook was nearly torn from my frozen fingers – marine painters must always expect to contend with the ele-ments and sudden changes of wind and weather!

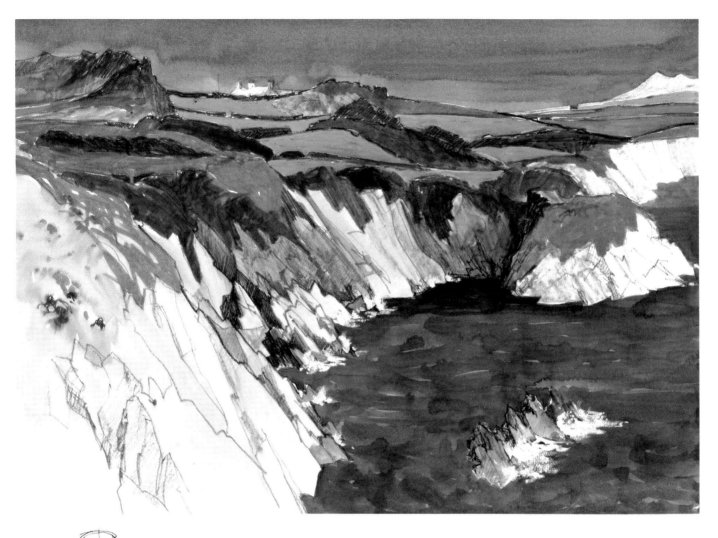

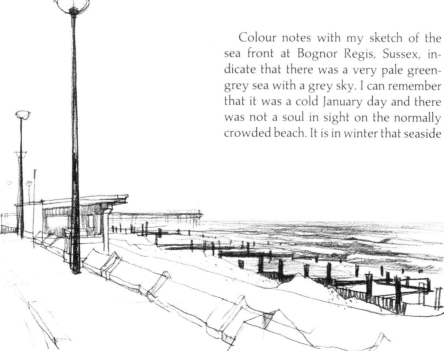

Colour notes with my sketch of the sea front at Bognor Regis, Sussex, indicate that there was a very pale green-grey sea with a grey sky. I can remember that it was a cold January day and there was not a soul in sight on the normally crowded beach. It is in winter that seaside towns can take on a different aspect. I actually prefer to sketch such places at that time of year. The sea was relatively calm but not without movement. The waves approached in a never-ending series.

Step-by-step in oils:

Scurdie Ness Lighthouse

As you may appreciate from looking at the tone of the sky in my painting of the Scurdie Ness lighthouse, Montrose (east coast of Scotland), the sketch had to be executed very rapidly. In my haste I did not allow enough space on the page to be able to draw the top of the lighthouse; however, a photograph taken at the time provided a good back-up as reference for the missing part.

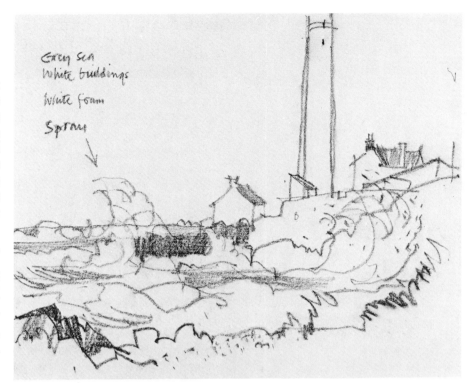

The height of the spray on this violent day was astounding. I carefully noted that it rose above the buildings, and I emphasised this aspect of the scene by making the composition vertical, and by exaggerating the height of the spray in the painting. When painting the sea you need to relate it to the sky. Sometimes the sky is reflected in a mirror-like surface of a calm sea, but this was a day of stormy skies, equally turbulent air and the breaking of the sea. It was heaping up and frothing pale grey, and the wildness of foam on the pinnacles of the waves sent up spumes of pure white in stark contrast to the dark tone of the threatening sky.

My memories were of the coldness of this grey day, and to alleviate this coldness in the painting I used a warm underpainting. I like to start an oil painting with thin paint, and sometimes I use a coloured ground prepared in advance. For the Scurdie Ness painting I used a white ground and made a tonal underpainting with burnt sienna and burnt umber. I used washes of prussian blue and lamp black on the roofs of the buildings which, in the final stages, were overpainted with a relatively warm mushroom colour. The sky was overpainted with prussian blue, burnt umber and a small amount of titanium white; hints of the warm underpainting show through. The sea was painted with titanium white and varying small touches of prussian blue and raw umber. Without any white, raw umber with a little prussian blue added makes a good colour to introduce on the rocks.

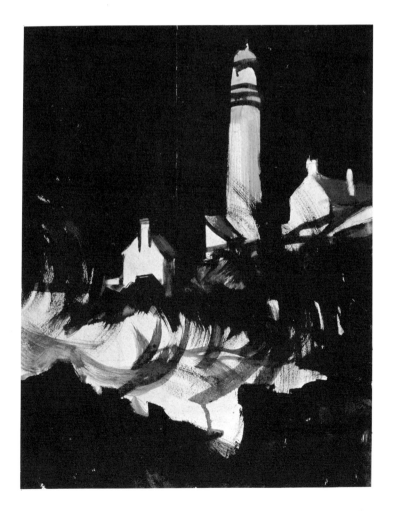

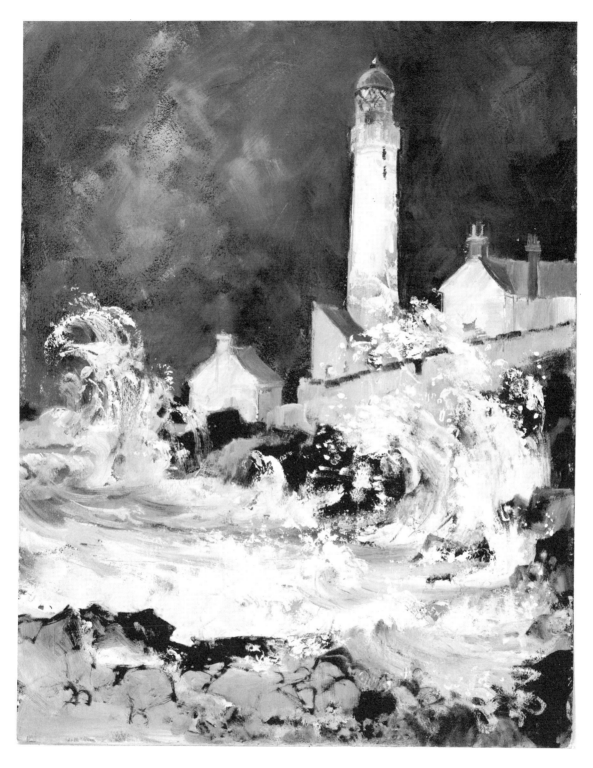

In the initial stages canvas was left unpainted in areas that were to remain pale in tone. This ensures that the maximum amount of light is reflected from the canvas through the subsequent paint. I applied thick paint with a palette knife to some of these light areas, particularly the spray. The knife was pressed flat onto the surface of the canvas using only a sparse amount of paint. As the knife was lifted off the canvas, the paint adhered unevenly which gave a broken mottled effect.

Scurdie Ness Lighthouse, oils, $12\frac{1}{2} \times 10$ in

Step-by-step in Watercolour with Masking fluid:

Sailing Boats

This painting was produced in a precise sequence.

Stage 1 I drew and filled in the outlines of the boats and sails with masking fluid ('Maskit' in the USA). This is a rubber latex solution which should be applied to the paper with a brush. The brush must be washed clean immediately after use, with cold water.

When the masking was dry I brushed a very dilute wash of paynes grey over the paper. The wash is brushed over the dry masking and saves having to paint carefully round the sails. I let the paper dry.

Stage 2 I dampened the sky with a brush and clean water and brushed in stronger paynes grey to form the clouds. The paint diffused into the damp paper to produce soft-edged clouds. I added a little viridian to some paynes grey wash and brushed it quickly in horizontal strokes over the sea. Because this part of the paper was dry, the quick brush strokes produced hard, dragged edges.

I let the painting dry and painted the hard-edged distance with a strong wash of paynes grey. When the paper was completely dry, I rubbed away the masking fluid with my finger tip.

Stage 3 This stage shows all the masking removed to leave the hard-edged sails as white paper. I started to add colour to the boats and sails. The painting is deliberately left unfinished to show the painting in progress. All that is needed how is a little more colour and modelling of the boats.

Stage 1

Stage 2

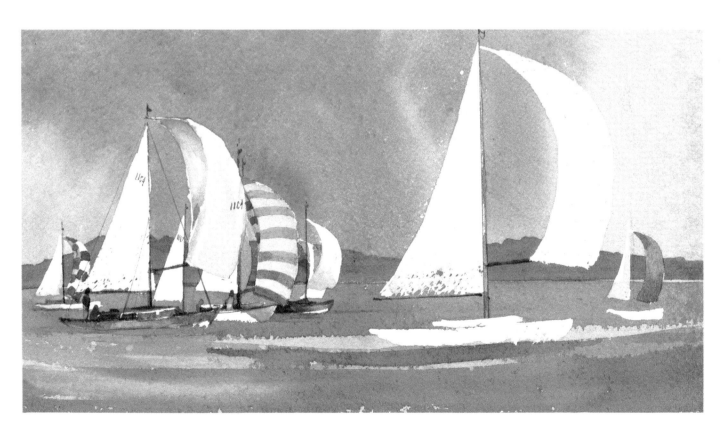

Stage 3

Force 4, watercolour and masking fluid, $5\frac{3}{4} \times 10\frac{1}{2}$ in

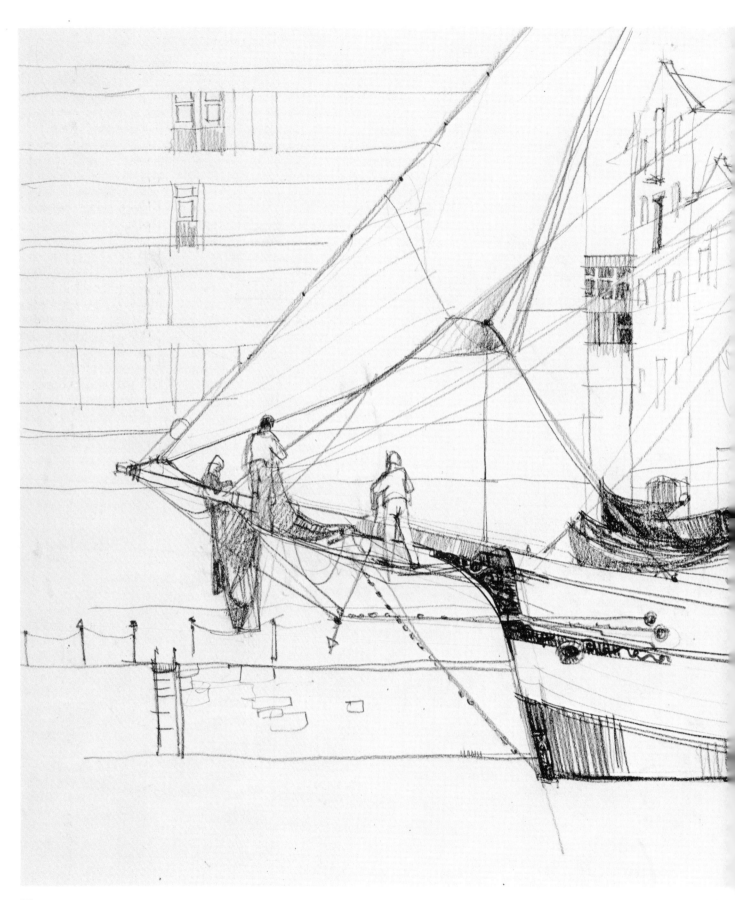

Drawing:

The 'Irene' at Bristol docks

This was a real find, a rare sailing schooner, long and sleek, with towering masts and web-like ropes festooned between the masts and hull. Its slender shape was beautifully decorated with painted scrolls and on close inspection the timbers showed the craftsman's skills.

As I looked across the dock towards the ship, I was delighted to see the crew 'tightrope' walking along the rigging in order to furl the sails. These were brown, a red ochre-ish brown; in contrast, the huge sail above was pristine white.

I learned later that the ship was undergoing a considerable re-fit, with plans to replace the large white sail with brown, the traditional colour for this type of craft.

Moira Huntly

Pastel:

The Green Sail

Several sketches were employed in the composition of the pastel painting of *The Green Sail*. Pastel is a versatile medium, for it can be used in a variety of ways. The tip of the pastel can be used for drawing, the side of the pastel stick can be used to fill an area with broad slabs of colour and a combination of both techniques can be applied to a painting. I chose pastel for this painting because I visualised the subject in these terms: line combined with slabs of colour.

I also visualised the subject in terms of strong tones and vibrant colour, and the pastel medium is ideally suited to this.

The composition is based on a grouping of interest across the centre of the painting. This group consists of a mass of boats, and I have aimed to see them collectively and not as individual boats. To do this I have only described certain parts of the boats in detail, while the rest of the boats are stated more simply as slabs of colour.

In support of this central group, I have placed large rectangular shapes of light; a big area of green light at the top is dissected by the masts. The harbour bottom to be seen in the lower left part of the painting is treated as one large shape, but broken with dots and drawing to create enough interest to invite inspection by the viewer without requiring too much involvement.

The whole painting attempts a balance of shapes and forms. The rectangle depicting the *Snowgoose* is balanced by the smaller blue rectangle at the base of the rudder in the bottom left.

Over the solid blocks of colour I have superimposed some light free meandering lines with a Conté pastel pencil as a change from the masted shapes.

The Green Sail, pastel, 19 × 26 in

93

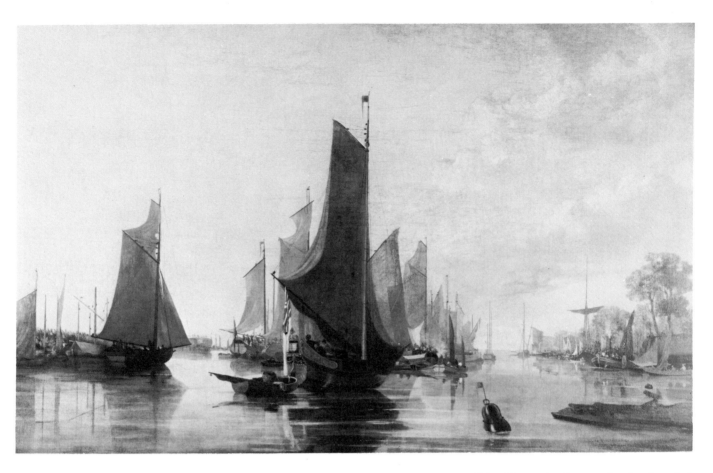

John Crome (1768–1821), who founded the Norwich School of painters, was a notable oil painter who painted many river scenes inspired by knowledge of the River Yare and also coastal scenes. Much of his painting was strongly influenced by the seventeenth-century Dutch masters, especially Ruisdael and Cuyp. It is interesting to compare *The Yarmouth Water Frolic* with the earlier Jan van de Cappelle painting on page 12, there is the same feeling of light and serenity of calm water and reflections. Marine recession is emphasised with the lighter tones of sky and water on the distant horizon.

A strong sense of design is evident, foreground sail shapes are silhouetted dark against the sky. The shapes are repeated and overlapped to make an interesting pattern of varied tone.

In sharp contrast to Crome's placid waters are the strong wind and choppy sea depicted in watercolour by François Louis Francia (1772–1839) in *St. Helen's*

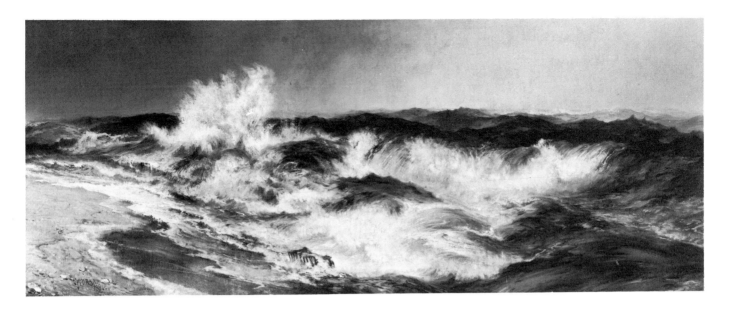

Roads. Francia was born in Calais, then came to London where he began painting in watercolour. He exhibited at the Royal Academy for many years, during which time Cotman also exhibited. There is a similarity in their work and I wonder if they were influenced by each other. Francia painted watercolours of coastal scenery, ships and the sea. In *St. Helen's Roads* he creates a fresh and sparkling marine atmosphere with washes that are simple and direct. There are flat areas of design: for instance the large light wave in the foreground is balanced by the light area of sky. The composition is unusual in that the horizon is almost exactly halfway down the picture. It is rare for an equal division of sky and sea to work as a satisfactory composition. Here, all the craft are heeling over in the strong breeze and the angle of masts and sails cutting the horizon serves as a link between sky and sea.

Thomas Moran (1837–1926) was one of America's many nineteenth-century romantic painters of marine subjects. They were influenced by the large number of British realist painters of the period who had emigrated to America.

I chose a reproduction of *The Much Resounding Sea* because it depicts the sea as I have seen it; spray cascading white against a lowering sky, and an awe-inspiring build-up to powerful waves, row upon row, ceaselessly coming in to pound the shoreline.

The horizon seems to be moving and the sky darkening as a squall passes across the sea, the painting captures this movement and atmosphere.

Paul Nash (1889–1946) was principally a romantic landscape painter, preoccupied with nature. The visual impact of his experiences during the First World War had a lasting influence in his painting which became highly individual. His painting became more formal and structured. *The Winter Sea* is semi-abstract, almost geometric and entirely different in concept and mood from Moran's painting.

Nash's treatment of the sea is powerful, I sense the pull of the moon and the vast empty space of sea and sky. The overlapping flat shapes of the waves create recession and desolation which epitomise the dark night of winter.

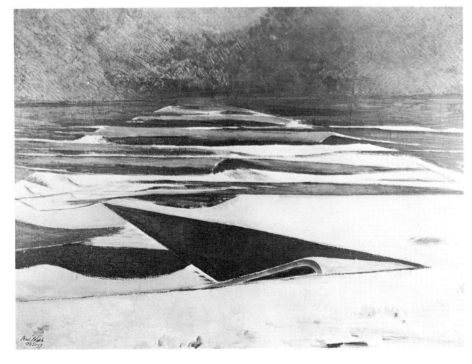

95

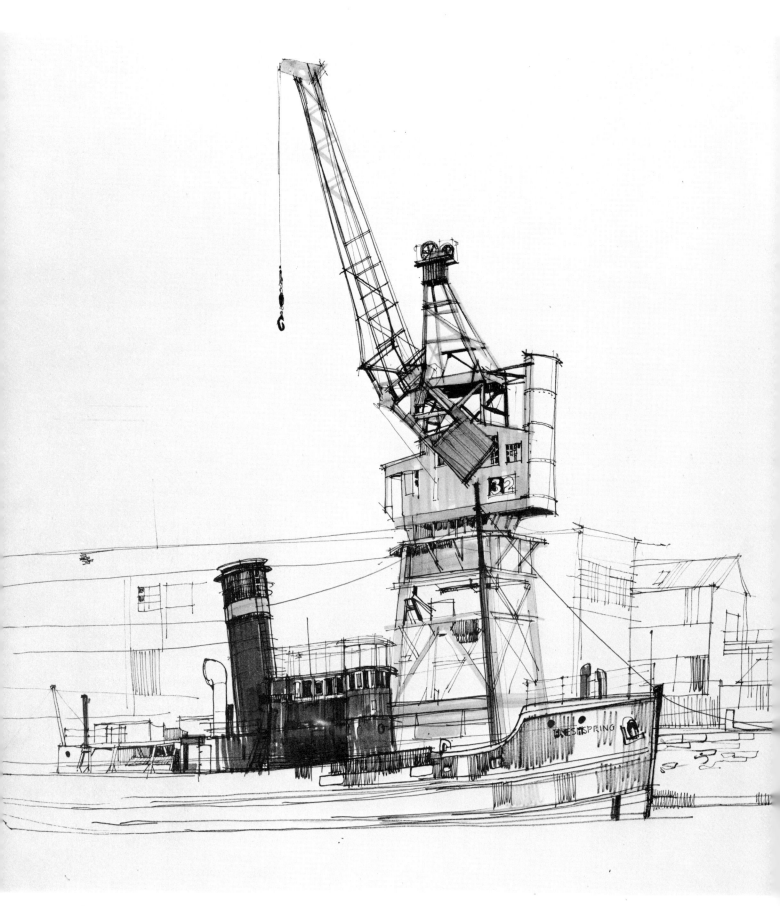

Chapter 6

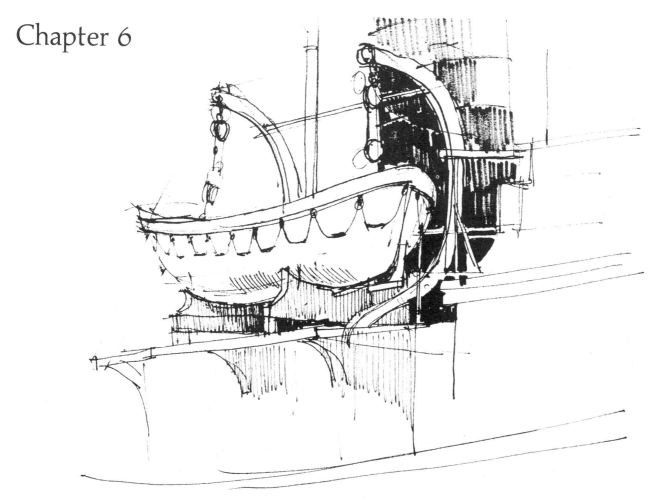

WORKING BOATS AND SHIPS

It is always advisable to get permission to draw in dock areas, for they are usually private or naval property. They can be hazardous places, but are full of the excitement of ships arriving from foreign parts, with the added visual excitement of tall cranes reaching into the sky, their intricate details in sharp contrast to the bulk of the hulls of cargo boats. I am always in awe of the strength and power of propellers swirling and churning the water as a ship manoeuvres out of dock.

On one of my visits to the small working dock at Glasson in Lancashire, all sketching ceased as I became absorbed in watching the masterly way in which a cargo boat was being edged accurately through a narrow space between jetties with only inches to spare. It was incredible to me that judgement could be so precise when the captain on the bridge seemed so remote from the ship's side. A sketch of the cargo boat being unloaded at Glasson Dock is shown on page 102.

The docks at Bristol have yielded a variety of interesting craft to draw, old sailing schooners amongst the new, and I spotted the elderly-looking craft opposite, which may have been an ex Royal Navy trawler, now converted to a tank cleaning vessel.

The dockside crane towered over it and gave a strong vertical element to the sketch, which is echoed by the funnel of the boat. The crane and the funnel enclose an interesting sky shape, and it could be that in a subsequent painting I would find some way of exploiting this. I find it interesting now to see that the emphasis in my drawing is on the top of the tower and on the cabin and funnel of the vessel. I expect that subconsciously I recognised that the squareness of the cabin echoes the housing on the top of the tower.

Perspective, scale and proportion

Large vessels present the same problems in perspective as smaller ones, and they do have the added problem of scale. It is not easy to draw a very large subject in simple terms, but whatever the size of craft, I like to commence with a faint centre line linking bow and stern, and then judge the length of the vessel against the height of mast and hull. I imagine the unseen base of a mast and try to determine where it is placed between the bow and the stern.

In these sketches made on the spot, I worked with a finely tipped black felt pen, to produce decisive drawing to convey the clean lines of the ships. Proportions and direction of the lines were carefully observed and analysed,

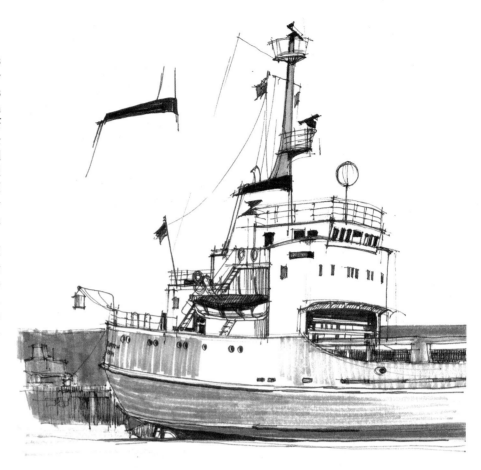

and then recorded without hesitation in order to make the lines positive and crisp. In order to satisfy this regard for clarity, I left a lot of white paper untouched. The sketches rely very much on the combination of thin decisive line and big areas of white paper.

The shading on the ships was deliberately paler in tone than the black drawing, and I used a thick blue-grey felt-tip pen. The accents of colour, yellow and red, were made with coloured felt-tip pens and, in places, red Conté pastel pencil.

The North Carr light vessel (see overleaf) was also drawn with a fibre-tip pen and a broad grey felt-tip pen. It was an intricate subject, and I was particularly attracted to the crisp angular patterns made by the girders, ladders and the lantern itself, sharp against a light sky.

For me, an essential part of drawing a complicated subject is to pay equal attention to the drawing of the shapes between objects. The girders supporting the lantern tower make diamond shapes of the sky, each differing in size and proportion. The sky seen between mast and rigging is divided up into a series of triangles, some are acute-angled, some isosceles and some are equilateral. Judging the proportion of these 'in between' shapes during the process of drawing is an important part of good draughtsmanship whatever the subject.

The lightship is a marine subject that lends itself to all kinds of interpretation when it comes to painting. It could also be interpreted in graphic terms as an etching, lithograph or linocut. The latter process might be especially appropriate to the angular incised like quality of the triangular and diamond shapes in the sketch.

It would be interesting to translate my drawing into definite patterns of black and white for a linocut. I am inspired by the woodcut by Edward Wadsworth, *Camouflaged Ship in Dry Dock, Liverpool, 1918* shown on page 140, which is an excellent example of a basic relief printing technique. Wadsworth makes maximum use of the impact of black and white patterns, and stylises the subject into abstract geometric forms ideally suited to this particular form of printing.

North Carr lightship at Anstruther
Harbour, Fife

100

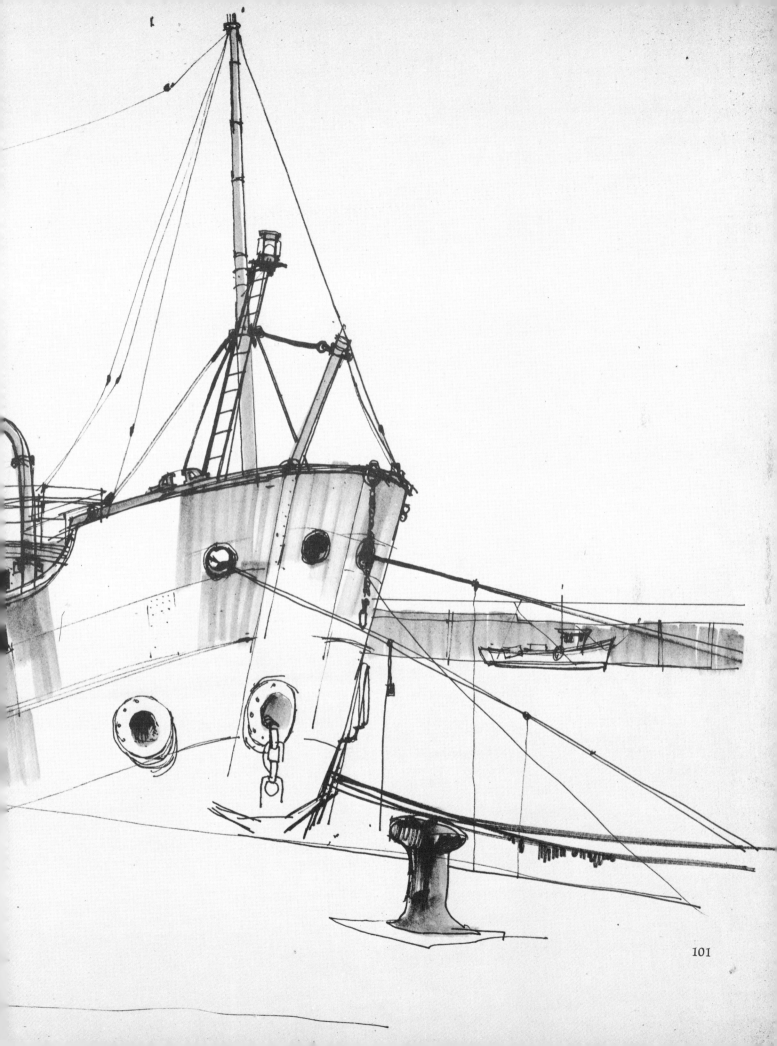

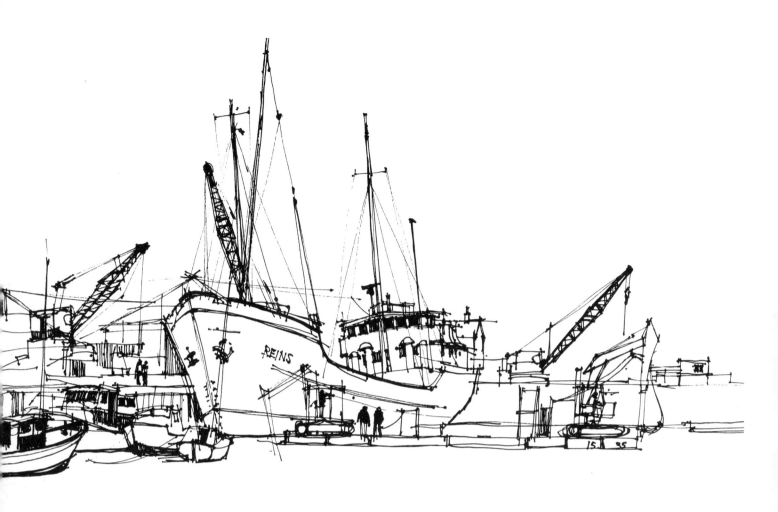

Fibre-tip pen, watercolour and gouache:

The 'Reins' unloading, Glasson Dock

I used a fibre-tip pen for this working sketch at Glasson Dock, Lancashire. Cranes and masts made a good pattern reaching into the sky and I noted that the ship had taken on a list as it was unloaded. The lighting was soft that day and some of this softness comes through in the painting.

The painting was made in the studio sometime later, but I often can recall by simply looking at a sketch the kind of day it was and this can subconsciously influence the mood of a painting. The only explanation I can think of for this memory is that there must be some association of ideas that automatically come into the mind when the sketch is viewed.

I took the unusual step for me, of starting the painting with a strong wash of rose watercolour applied with a very big brush. As is usual with watercolour the strong wash dried much lighter, but with enough strength to permeate the painting. It shows through the pale green gouache overpainting of the sky and grey-green water, and is left untouched on the roofs of the sheds.

The painting is a fairly faithful reproduction of a sketch and shows the ship and harbour as they were. I have not attempted to treat them in an impressionistic way or as a design of patterns and tones. I simply felt that the subject was interesting in itself.

102

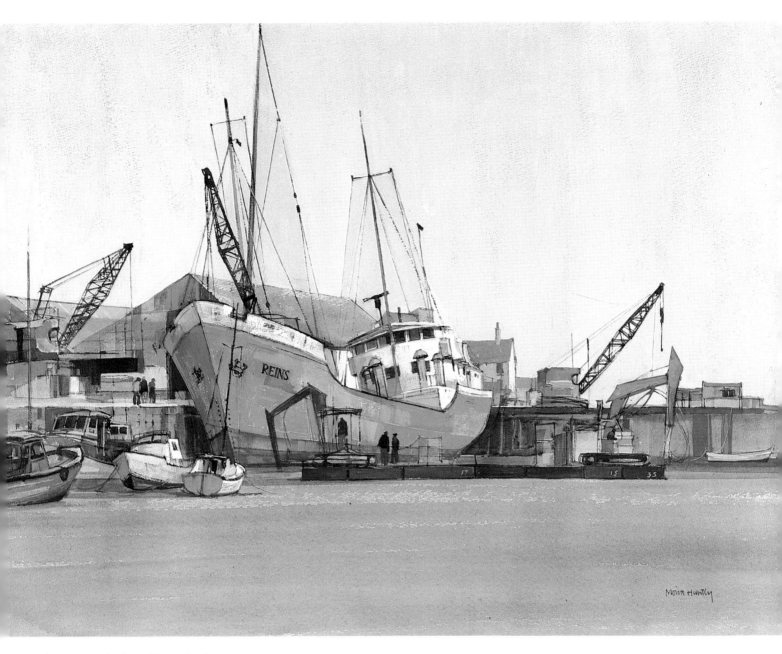

The 'Reins' Unloading, Glasson Dock,
watercolour, $20\frac{1}{2} \times 28\frac{1}{4}$ in

Watercolour and gouache on tinted paper:

Fishing Fleet at Kinlochbervie

I have included these Scottish deep sea trawlers at Kinlochbervie, Sutherland, as appropriate to this chapter on larger working boats.

Most of the painting was done on the spot. I used a tinted paper and started with watercolour washes, then used gouache on top. The painting is really concerned with shapes, the machinery on the left made an immediate appeal when I first saw this subject. Dark and sharp-edged, the shape of the hoists seemed to reach upwards towards the sky and then beyond them, the masts of the other boats echo their direction.

In contrast to the general feeling of diagonal movement in the painting, the light shape of the deep sea fishing boat's cabin gives a solid stabilising effect to the composition. Without it the painting would be overful of activity and restlessness. To emphasise its importance within the composition I exaggerated the light colour of the cabin. The square of light, below and to the left of the cabin, is important. I deliberately made it slightly greyer than the cabin so that it is secondary to it. It provides an intermediate tonal value between the lower parts of the painting and the light on the cabin.

As always in my paintings, I looked for some repetitive elements. The sterns of the three boats on the left lent themselves perfectly to this purpose. I subdued the colour of the nearer one so that the main areas of colour are located near the cabin. The hard edge of the mountains helps to tie the array of vertical masts together and provides a horizontal element in the painting. Within the mountains I worked with vertical brush strokes that relate to the vertical movement elsewhere.

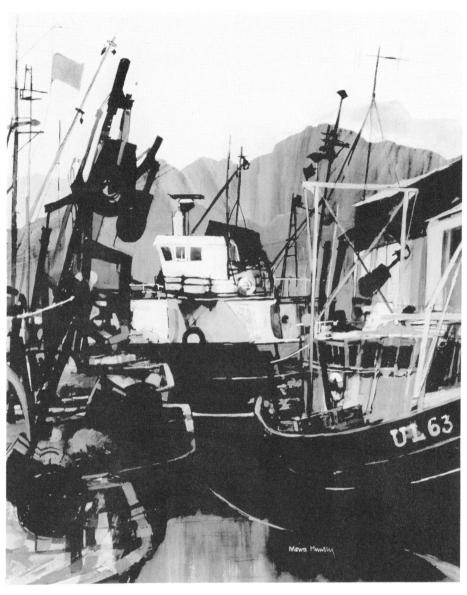

Fishing Fleet at Kinlochbervie, watercolour and gouache, 13 × 6½ in

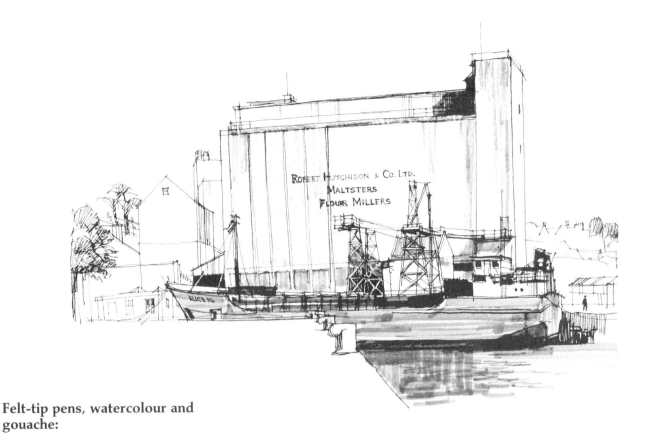

Felt-tip pens, watercolour and gouache:

Kirkcaldy Harbour

My sketch was made quickly, to register the arrangement of shapes that interested me. I liked the big square mass of the building, itself divided into narrow vertical and horizontal rectangles. These rectangles are repeated in the main hull of the ship and in the bands of red on the hold. The 'V' shape of the roof of the smaller buildings and the diagonal of the foreground quayside are a foil to the rectangular shapes.

I drew with a felt-tip pen, and the colours on the ship and in the water were added with quick strokes of broad marker pens.

The sketch is a reasonably factual record of the scene and I took care to judge the various proportions correctly. The height of the building was compared with its width, and then compared with the length of the ship. I observed the dimensions of the distant buildings and noted their heights relative to the big building. I think that this kind of analytical drawing, that is, the measuring of intervals as well as the whole, gives a sound base to work from. Knowing that a drawing is fairly accurate gives me confidence when I start to paint back home in the studio – sometimes this is a long time after making the drawing, but time does not matter. I keep all my old sketchbooks, they provide me with an ever-increasing library of reference.

In the studio, I feel entitled to make adjustments to help convey my own feelings. Paintings are a personal interpretation of the facts that the drawings provide.

For my painting of Kirkcaldy Harbour overleaf, I thought that the bulk of the building was an important feature of the subject and I wanted to express this. I have achieved this aim by the simple device of taking the tower part of the building out of the top of the painting. There are very few adjustments elsewhere in the proportions. You could check this by actual measurement, for example, the width of the building relative to the length of the boat is unaltered, and the width of the sky area on the right is in the same ratio to the width of the building as in the sketch. I am not saying that the artist should not make adjustments if it helps to express a particular interpretation, provided that they are done discreetly and enhance the composition. In this painting there simply was no need for such liberties.

The painting began with loose washes of watercolour, mainly hookers green over the top half and cadmium red over the bottom half. When the washes were dry, the subject was drawn with a sable brush and a dark tone of watercolour. When this was dry, I superimposed gouache, letting the base colour break through in places.

In order to concentrate the main mass I kept the harbour light in tone, repeating the sky colour. When I came to paint the buildings on the left I did let my imagination run free a little. I adjusted the buildings to make a pattern that interested me.

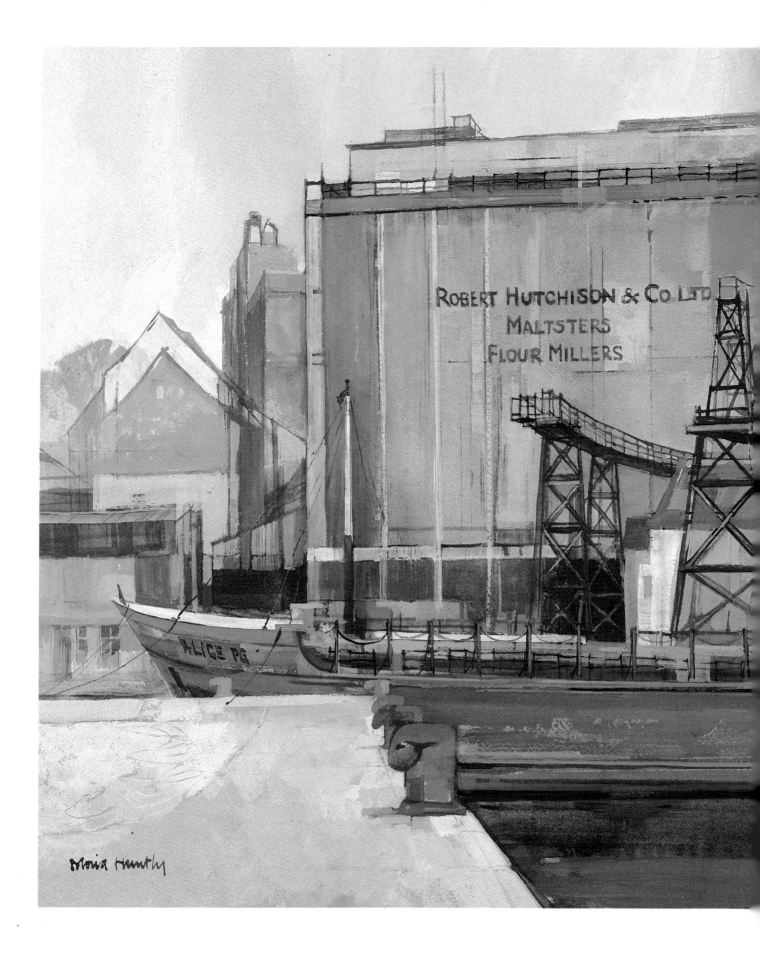

ROBERT HUTCHISON & CO LTD
MALTSTERS
FLOUR MILLERS

ALICE PG

Kirkcaldy Harbour, watercolour and gouache, $15\frac{3}{4} \times 23\frac{3}{4}$ in

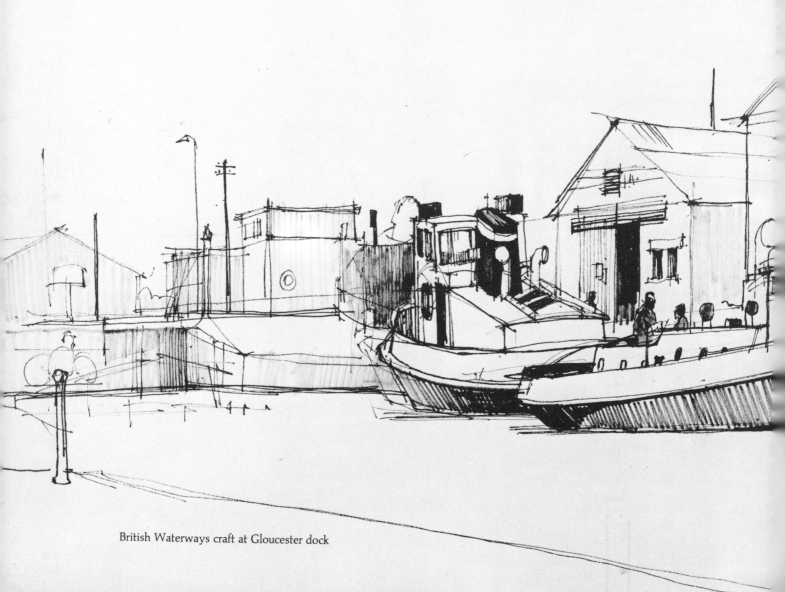
British Waterways craft at Gloucester dock

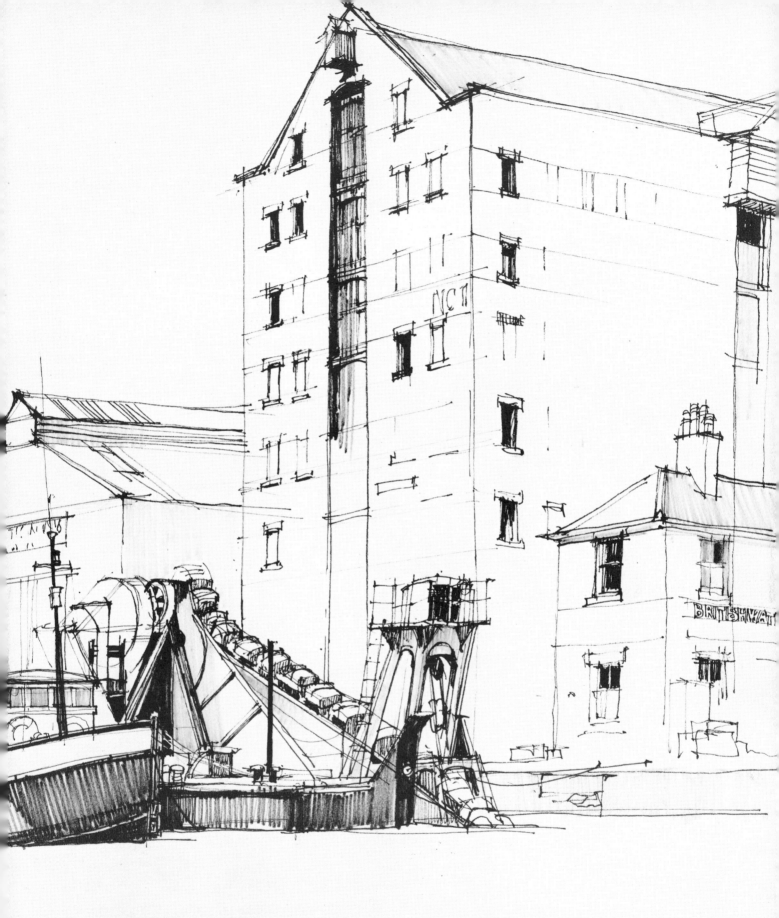

109

Step-by-step in acrylics:

Heavy Weather

I used the textured surface of watercolour paper for this demonstration with acrylic paint. I like the versatility and quick-drying power of acrylics – versatile because you can dilute them with water and apply thin washes as in watercolour painting or, at the other extreme, you can apply them thickly as heavy impasto, just as you can with oils. You can also paint over thick dry paint with thin transparent washes to give a glazed effect.

Stage 1 My sea painting starts with thin washes of mixtures of pthalo blue and vermilion applied freely with a large soft hair brush. Areas of paper are left untouched to represent crests of waves, and the brush strokes attempt to follow along the movement of the waves.

At the horizon the washes have been deepened and I have started to indicate the ship.

Stage 2 More washes of less dilute acrylic are brushed over the sea, introducing secondary movement into the wave patterns but emphasising the trough running before the crest of the wave. The ship is painted as a silhouette looming dark against the sky, and I paint the sky with thick opaque acrylic, applied with a small square-ended hog hair brush.

Stage 3 The distant coast is left as the initial thin wash, thick white paint is applied with both brush and palette knife to the cresting waves and foam. The painting generally continues to be built up with more opaque paint and finally glazes of thin acrylic are brushed over the foreground foam leaving a few touches of white spray.

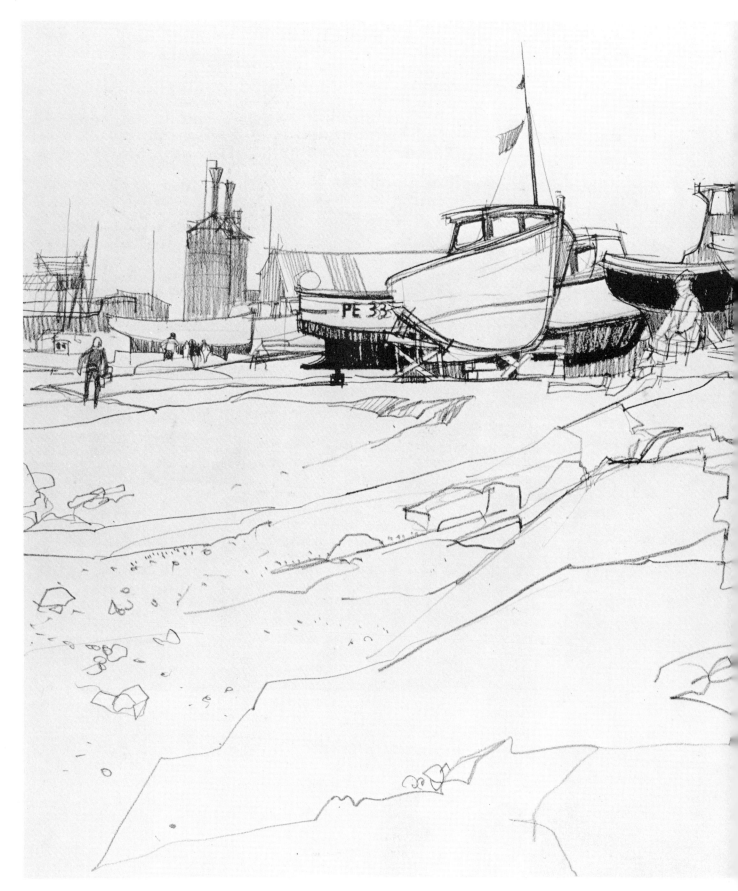

Chapter 7

BOATS IN THE LANDSCAPE

Coastlines, estuaries, harbours and boatyards – these are areas where the marine painter and the landscape painter overlap. There is an affinity between boat shapes and buildings and the constructional problems confronting the painter are similar.

Aesthetically the combination of boats with a townscape, or of boats with natural forms such as plants and trees can be very rewarding. Knowing something of how to draw boats, enables the 'holiday' painter to feel confidence when including boats in a landscape.

My drawing at Poole in Dorset is of a boatyard which seemed to be an extension of the back gardens adjoining the beach. Figures included in the sketch were useful in providing scale to the boats, and to the distance.

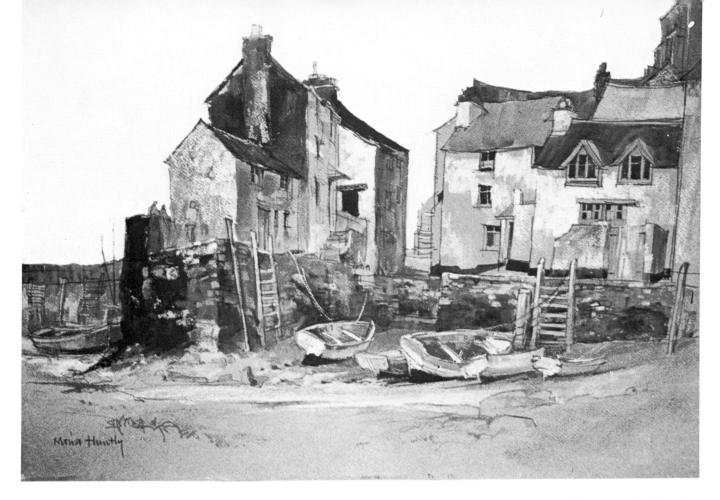

Polperro, pastel, 15½ × 25 in

Pastel:

Polperro

The pastel medium is exciting and very versatile. A stick of pastel can be used on its side to paint with; the tip can be used for drawing; the medium can also be stippled, rubbed in or scumbled.

In my pastel painting of Polperro, the harbour buildings dominate the scene and the boats lie idly at low tide. The gentle curves of the rowing boats serve as a pleasing foil to the solid mass of the buildings, and the mooring ropes link the two elements in the painting. There is an economical use of pastel evident in this painting. The subject was drawn with a stick of pastel on a warm grey paper, and much of the paper was left uncovered in the final painting to represent the mid tones. By way of contrast, the sky was painted solidly with light pastel pressed firmly into the grain of the paper to give a different flat tone. Sparkling lights were made by dragging pastel lightly over the textured paper.

Conté pastel pencil:

Harbour near St. David's, Pembrokeshire

Brown Conté pastel pencil was used for this drawing, on cartridge paper.

This creek is a cleft between steep headlands, and I climbed up so that I could look down on the water. From this high vantage point I could also look out across the vast open expanse of sea, but I preferred to concentrate on the compact little scene below. This small fragment presented a ready-made composition with the passage of water lying diagonally across the paper.

The water is divided into parts by the distant harbour wall; the nearer part is large and occupies almost a quarter of the sketch, and leads towards the smaller distant area.

With the exception of the tiny boats, I left white paper for the water, and intensified this by darker tone on the hillside. Notice that the hillside on the left is darkened only where it meets the water. To have made the whole of this part dark would have made a competitive dark equal in area to the light water.

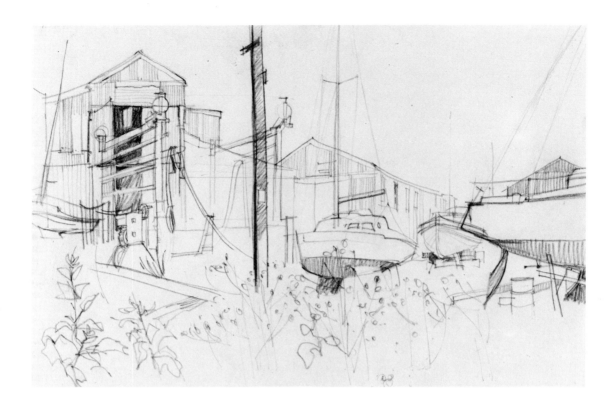

Charcoal pencil:

Boatyard at Beaumaris

This boatyard stands immediately alongside and above the beach. A stony bank sloping to the beach is covered with flowering weeds and large-leafed plants.

The scene was a conglomeration of large sheds, small sheds, boats, empty oil drums, and various pieces of machinery. There was no obvious arrangement in all this equipment, and no obvious composition for the painter's eye, and so I sketched it as it was – a jumble of maritime things. Looking at the sketch now, it seems that I instinctively emphasised the large post to give some sort of 'anchor' to the scattered bits.

Step-by-step in pastel:

Boatyard at Beaumaris

Back in the studio I used pastel to paint from the sketch. My thinking was that the chunky direct slabs of pastel would give solidity and cohesion to the cluttered material. This cohesion is also helped by using blue as the base colour for all the buildings. This one colour helps to bind them all together. I disentangled the boats from the background sheds by making them slightly larger and more contrasty than in the sketch.

Stage 1 I begin the painting on grey pastel paper, by drawing the main outlines of the sheds and boats with a brush and burnt umber watercolour. Then I mass in a large area of background and parts of the foreground with washes of cobalt blue watercolour. When this is dry I begin to add pastel, keeping it in flat positive strokes of colour and letting the background blue break through.

The painting so far is a simplification of the sketch, with broad slabs of colour

and firm drawing. Pastel is a good medium for this combination of drawing and painting.

Stage 2 (final) As the painting progresses blue still predominates in the boatyard sheds which provide a background tone to the boats. Once the sky is completed, the silhouetted shapes of the shed roofs and the intervals between create a sharp, angular pattern, which cuts across the painting. Patches of light in the sky are echoed by the dappled light on the ground between the boats.

I became interested in the weeds, their floppy leaf shapes were a nice foil to the angularity of the rest of the painting. The difficulty here was in not overdoing the foreground details, and I aimed to paint the leaf shapes with soft greens, grey greens, terre verte, warm greys and blue greys with an occasional sharpening up of form. These middle tones in the foreground link up with the tones on the sheds. The boats make light horizontal shapes against the grey background.

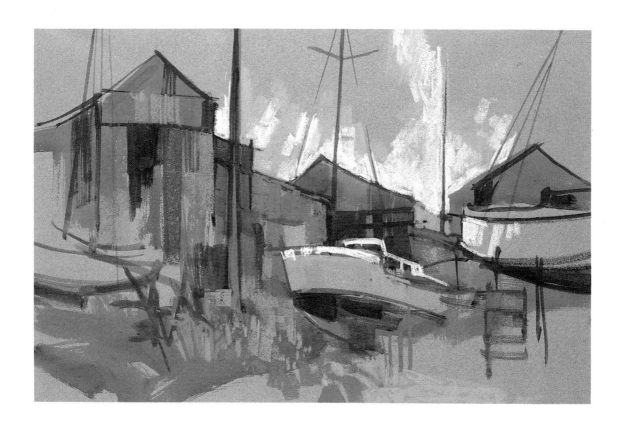

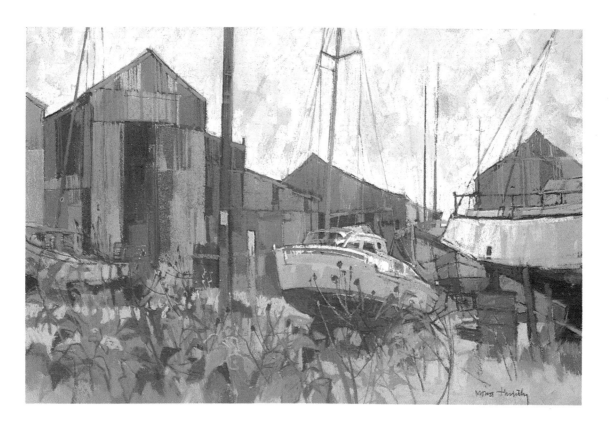

Boatyard at Beaumaris, pastel, $13\frac{1}{2} \times 20\frac{1}{2}$ in

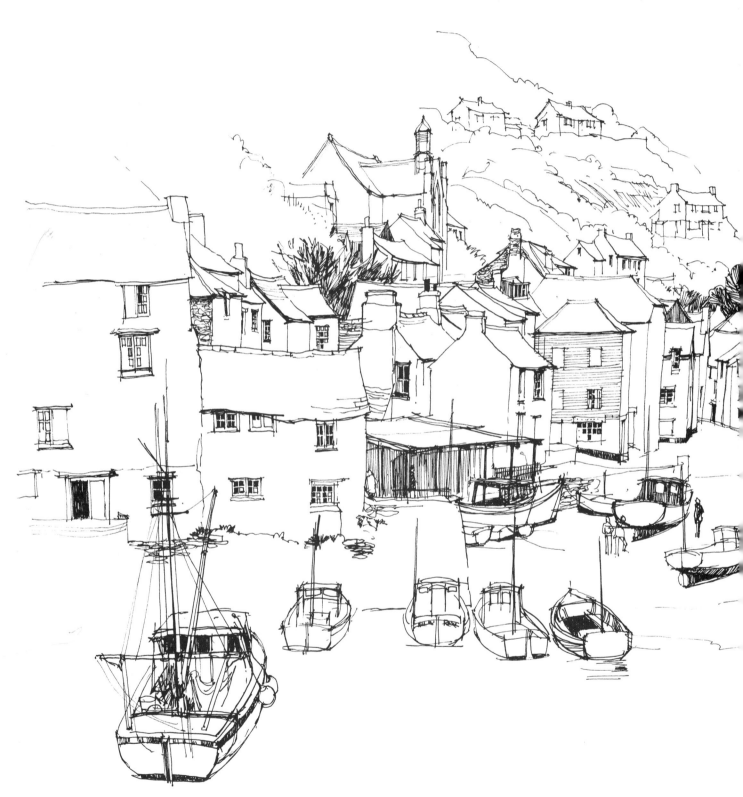

118

Fibre-tip pen:

Polperro

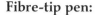

Boats and buildings cluster together in this large sketch of Polperro harbour at low tide. It is a complicated subject and required a large A2 sketch pad. I started the drawing one evening but within an hour, the tide began to come in and the light began to fade. I returned to the spot to complete the drawing the next evening, knowing that conditions of tide and light would be similar.

The sketch is a starting point, full of information that can be interpreted as a studio painting in many ways. At the moment I tend to think of this sketch in terms of a large oil painting, perhaps a semi-abstract riot of colour inspired by a strong evening light. Alternatively, I could paint with large transparent washes of watercolour, interpreting the evening light as soft and misty with hints of the drawing of the buildings and masts showing through. Either way, it is easier in the studio to pursue this freedom of choice and allow your own imaginative ideas to dominate.

I am often asked how to commence the drawing of a complicated subject — where to start? In this case I decided that the placing of the bridge was an important key to the whole sketch.

I mentally planned to place it off centre, allowing plenty of room for the boats and buildings I wished to include. My next thought process was to judge how far up the paper to place the bridge. In order to ascertain this, I had to judge the position of the boat (bottom left) as opposed to the houses on the hill (top right). Having done my thinking, I started drawing the quayside sheds (left of centre) without any preliminary pencil drawing. I gradually expanded the drawing from this point, comparing the height and width of each building and boat as it was sketched in, to the height and width of the sheds. This continual assessment by looking horizontally and vertically at the relative positions of each part of the subject becomes an automatic part of drawing. As I commenced the buildings seen to the right of the bridge, I glanced across at buildings already drawn opposite, and compared relative heights of chimneys, width of walls and size of windows. The width and height of boats and masts were also compared to the buildings. It sounds laborious, but, like learning to change gear when driving a car, after a while it happens instinctively.

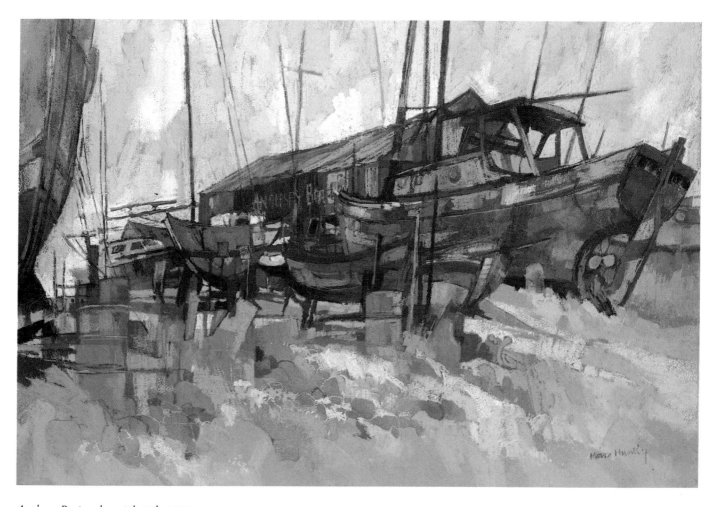

Anglesey Boatyard, pastel, $18\frac{1}{2} \times 27$ in

Pastel:

Anglesey Boatyard

This is a rather aggressive painting. The viewpoint on the beach is low and so the boat shapes seem to thrust upwards to make a forceful composition. The varying directions of the masts give a feeling of animation to the painting although the boats are static.

I sketched on the spot, carefully keeping an eye on the tide behind me. I used a large sheet of grey Canson pastel paper and a dark grey pastel stick. It is unusual for me to work this size on location and it was not easy in the wind, but a large stone suspended from the easel with string prevented it from blowing over.

A few strokes of pastel here and there provided colour reminders, so that the painting could be completed in the studio. I painted the sky with flat slabs of pale pink, green and blue pastel placed directly on the paper without modelling or rubbing. The sense of blending is obtained by keeping the three colours all the same tone so that there is little contrast between these flat areas of colour. The foreground is treated in a similar way using the same colours as the sky and introducing some of the colours in the main mass of the boats. As a slight contrast of treatment I have indicated a few rounded stones.

The boats are kept as a dark mass in the middle of the painting. There is an awareness of boats rather than a detailed study of each one. My aim in the painting was to achieve recognisable forms within an overall abstraction. In contrast to the pale greens and pinks of the sky, I have kept to the bold strong colours that I had originally indicated on the boats – french ultramarine, raw umber, prussian blue and burnt sienna.

The estuary sketch at Abersoch in North Wales, made with a felt pen, will be interpreted as a studio painting similar in concept to the Anglesey Boatyard painting. I will search for some abstract elements in the sketch and build up the painting around these, aiming for a balance of realism and abstraction. I shall need to consider the work before making a start, but my immediate reaction is that the rectangular shapes of the buildings could provide a basis for abstract interpretation. I may also exploit the patterns of light and dark. The boats could be treated realistically although, even so, I would probably include some abstract echoes of the building shapes within the boat structure.

121

Drawing, watercolour and gouache:

Paynes Boatyard

When I visited Paynes boatyard near Bosham, West Sussex, I was strongly attracted by the vertical pattern of posts along the jetties, and their subtle variations of angle and height. This variation of angle and height is echoed by the masts in the foreground and yet again by the distant masts.

It must be incomprehensible to a non-painter why a seemingly ordinary group of objects or people should inspire enough excitement to cause almost a panic in the rush to capture it on paper. At these moments anything will suffice to draw on or with. Many times sheer frustration is experienced halfway through a drawing, when it is realised instinctively that the drawing is not 'working', and the initial impact of the subject has eluded capture on paper. This time I was not too displeased with my effort.

I used a large drawing pad and a Conté pastel pencil and reinforced some of the masts with straight lines drawn by using the edge of another sketch pad as a ruler. A few colour reminders were added with broad felt-tip pens and coloured Conté pastel pencils.

Because of my haste, the jumble of boat shapes between the posts is not altogether decipherable, but nevertheless provides enough information to form the basis of a painting.

The painting was made in the studio. The painting is mainly concerned with the pattern of masts and jetties, for it was this particular aspect of the subject that had originally attracted my interest. I did not 'square up' the drawing in order to enlarge it and transfer it onto the 'canvas', since this would have inhibited my interpretation.

My way of working is to place the sketch a few feet beyond my easel in such a position that both sketch and canvas can be viewed at the same time. I study the sketch carefully before registering the first basic lines of the composition on the canvas, and then stand back to view both sketch and painting. This activity is repeated frequently as the painting progresses.

The process of distilling from the sketch the essential relationship can involve selection, simplification and, sometimes, exaggeration in order to convey personal feelings.

In *Paynes Boatyard*, the jetties make important 'horizontals' in the painting, slightly undulating to give an interesting sinuous movement across the painting. The supporting posts lean sideways, in an almost precarious attitude, and are echoed by the distant masts. The foreground masts seem at first sight to have been haphazardly placed, but in fact their positions are carefully exploited with a group on the left leaning slightly in various directions, and their spacings varied. To the right there are two masts and then a single mast, and their heights are varied.

Within this strong linear framework, the boats make curved and tapering shapes, tilted at the bows, reaching out of the picture. The general trend towards the left of the picture is arrested by the few boats facing towards the right.

The skeletal framework of the jetties serves to highlight the distant sunny land. These rectangular light shapes are repeated throughout the painting.

Since I planned that much of the final painting would be pale yellow, I started with a wash of lemon yellow watercolour over most of the painting, adding payne's grey to the wash in places. This first wash can be seen in many parts of the final painting. Then I drew the main structural lines of the jetties and boats with a sable brush and payne's grey. Some of the lemon wash was strengthened with raw sienna, the background grey-greens are a mixture of payne's grey and lemon yellow. Antwerp blue was brushed over the lemon yellow wash to create the accent of pale turquoise below the distant white boat and varied mixes of burnt sienna and raw sienna were used for the warm areas in the painting. Light areas were built up with gouache but the painting was executed with very few colours and its strength depends on the distribution of light and dark and decisive drawing.

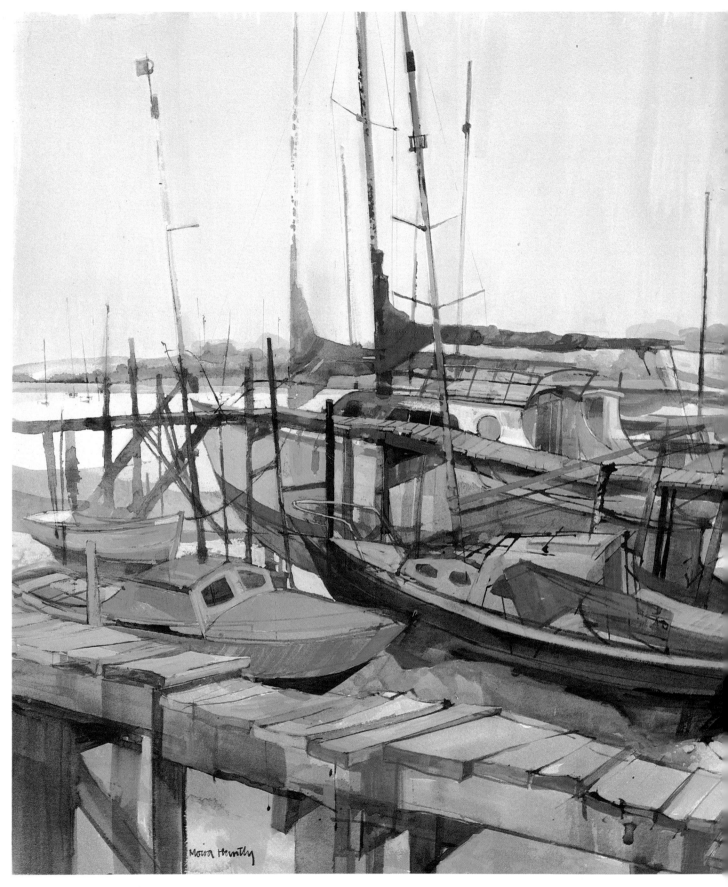

Moira Huntly

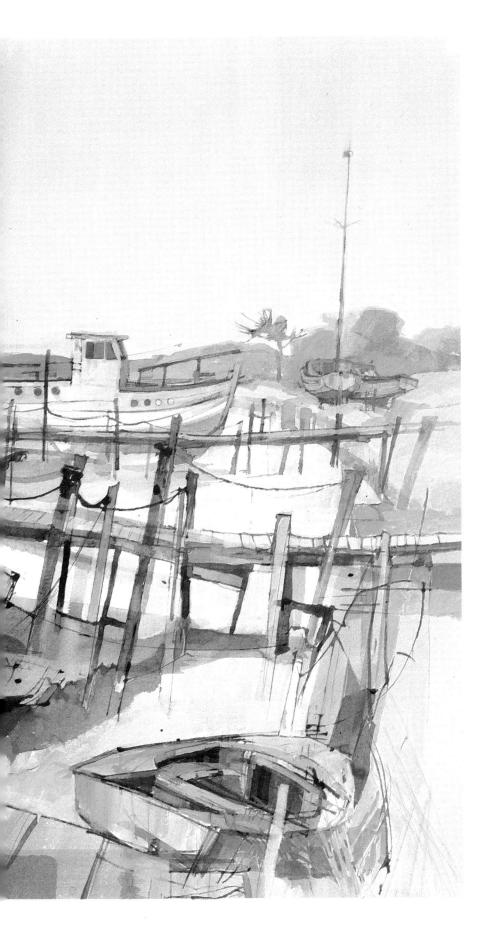

Paynes Boatyard, watercolour and gouache,
20 × 29 in

Drawing:

Red Wharf Bay, Anglesey

The wide estuary at Red Wharf Bay has inspired many paintings of sea and sky. This time the boats are far away in the distance and only just discernible on the far side of the bay. I was particularly impressed by the snaking almost abstract shapes made by the sand and mud banks in the foreground contrasted with the spiky sea grasses.

127

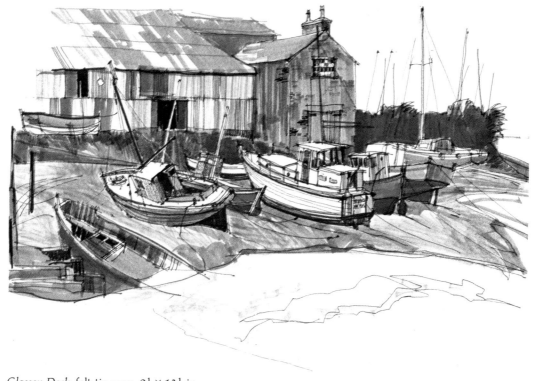

Glasson Dock, felt-tip pens, $9\frac{1}{2} \times 13\frac{1}{4}$ in

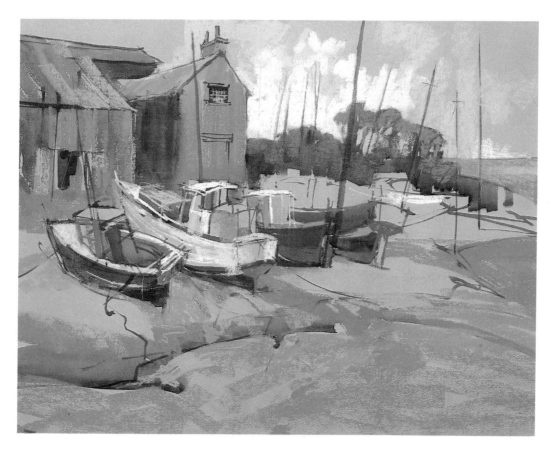

Glasson Dock, pastel, 15×19 in

Chapter 8

TECHNIQUES AND MATERIALS

I would have needed to write at least another book in order to include every material and method known to artists, and so in this chapter, I concentrate only on the methods used elsewhere in this book. I enjoy painting in most media and try to keep an awareness of the effects achieved. Sometimes effects gained in one medium can be translated into another, and so we gain a wider sensibility. I also like to explore mixed media and study the aesthetic impression that one medium may give when combined with another.

Drawing and painting are ways of making marks on paper or canvas. Methods that concern us here include pencil and pen line work, brush line work, and combinations of line and colour. The paint may be applied by brush, knife, scumbling, splatter and with any tool, even the finger, to obtain the surface characteristics of the subject.

The boats on mud banks at Glasson dock in Lancashire, at low tide, show the same subject interpreted in totally different media.

The drawing in fibre-tip and felt-tip pens shows stronger darks and sharper silhouettes than the wash and pastel sketch which has softer edge values and less contrast between mud bank and the sea beyond.

The top drawing was begun with a thin freely drawn black line made with an Edding Profipen 0.3 and continued with areas of tone quickly applied with a broad water-based felt-tip pen. On this particular sketch I used a mid tone of grey and a darker tone of blue grey. The lightest broken greys were obtained with a felt pen that was beginning to run out. This gave a pleasing dry brush effect. Touches of colour were added with

green and yellow felt-tip pens and warm colour indicated with a red Conté pastel pencil. My reason for this change of medium is simple – I did not have the right felt-tip pen with me! As it turned out I was pleased to make new discoveries about the visual effects gained by combining the ink of a felt-tip pen with Conté pastel pencil and have often since then deliberately combined the two mediums in a sketch.

Inks in Profipens are light fast and waterproof and red Conté is a traditional permanent medium but the ink from felt-tip pens will fade in time. My sketch is a working sketch and not intended for display, but if it had been my intention to exhibit the sketch I would have added tone with a permanent medium such as thin acrylic or water colour.

The lower sketch was drawn with a brush and ultramarine blue watercolour on Canson mi-teinte pastel paper to make this a permanent sketch that could be developed much later as a painting.

In this sketch the loose grey and blue-grey watercolour washes are used in the same way as the felt-tip pen washes in the sketch above but I was working on a toned ground and superimposing the light tones.

Pen and ink

Materials

Metal nib dip pens: for use with Indian, white or coloured inks (coloured inks are not guaranteed permanent).
Felt- and fibre-tip pens: useful for quick sketches but the ink is usually not light fast or waterproof.
Rotring and Profipen: these carry permanent black ink.
Smooth cartridge paper is good for ink drawings, but not too thin a quality or the ink will sink through to the other side.

Ink drawings are best when they are freely drawn, even a few inadvertent blots can add to the spontaneous visual excitement of a sketch. A very complicated subject, however, may need a few lightly pencilled guide lines. Do not attempt to rub off the pencil lines if you are using Indian ink, until the drawing has had several hours in which to dry.

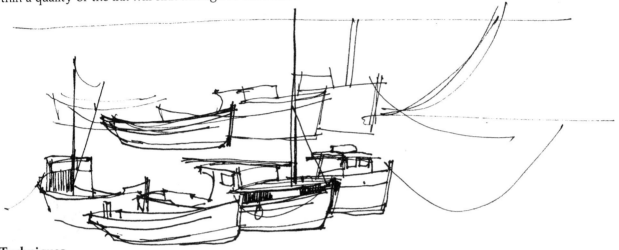

Techniques

Fig. 1 This shows a freely drawn pen-and-ink sketch executed with light pressure so that the metal nib does not dig into the paper.

Fig. 2 This sketch employs vigorous line work, cross hatched in places to suggest the various planes of the rock formations and to create tone.

Fig. 3 Here, line and solid areas of black tone are combined to create strong pattern. Tone is confined to the boat to make for greater impact.

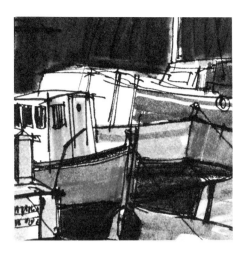

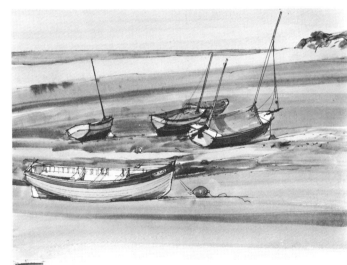

Fig. 5 The second detail from the same picture shows the underside of the boats discreetly textured by the use of dry Conté pastel pencil. On the keel the Conté is smoothed over with a felt-tip pen to an almost velvet finish.

Fig. 4 In this detail from the top colour sketch on page 128, the windows are drawn with a thin pen line, and the darks filled in leaving white paper for the bars. Some panes are varied in tone by the use of a grey felt pen. The bricks are drawn with Conté pencil and blended with a broad felt-tip 'wash'.

Fig. 6 A waterproof Edding Profipen was used for this line and wash drawing. The fine line was appropriate to the sleek lines of the boats. Then the paper was covered with broad washes of watercolour, except for some areas left uncovered for the white parts of the boats.

Fig. 7 Here, the drawing was made with a stick dipped in Indian ink to produce rough lines appropriate to the rocks. Then colour washes were applied and some further ink line added, which softened and spread into the damp paper to give a wet-into-wet effect.

131

Pastels

Pastels have been in use for over two hundred years: they have been regularly used by such painters as Quentin de la Tour, Chardin, Degas, Odilon Redon and Picasso.

It is not generally appreciated that although pastels are fragile, they are probably the most permanent medium. They do not fade, darken or crack and, if they are protected behind glass, pastels remain as fresh as the day they were painted.

Materials

Colour Pastel consists of pigment, plus a little gum and resin, compressed into stick form. The colour is ready mixed and so there is a large range, from beautifully subtle shades to very brilliant. Each colour is graded in 6 or 8 tones from light to dark. In the UK, it is usual for the lightest tone to start at 0, whereas in America it is usual for the darkest tone to start at 0. Fig. 1 shows a tone range of blue-grey.

With so many colours and tones to choose from, it is advisable to choose a few individual sticks of colour and gradually to build up a collection. I started with a basic palette of two or three different tones of raw umber, burnt umber, burnt sienna and cool grey, with a light tone of ultramarine, two tones of olive green and green-grey and a warm white.

Paper Ingres or Canson (in a large range of colours), cardboard or sandpaper. Pastel requires a support with a tooth or grain, so that the dry particles of pigment will adhere to the surface.

Fixative It comes in a bottle which requires a spray attachment through which to blow, or in an aerosol can. A light spray will help to hold the pastel, and more pastel can be worked on top if the surface has become dull.

Techniques

Pastel is versatile, it is both a drawing and a 'painting' medium. I peel the paper from my sticks of pastel and break off a length for painting. Marks can be made with the tip of the pastel, Fig. 2, or by using the side. Fig. 3 shows marks made with the side of different lengths of pastel, this compares with having different sizes of brush. I separate the colours into containers keeping together, for example, all the reds, the light greens, dark greens or pinks, and I fill the containers with ground rice or cotton wool to protect and keep the pastels clean. Colours that are being used can be laid out on corrugated paper, to prevent them from rubbing against each other.

Mixing Painting effects are instant because pastel is a dry medium with no mixing. Colours can be placed close together and overlapped or cross hatched as in Fig. 4 to simulate mixing.

2

3

They can also be blended by rubbing, Fig. 5, but this rapidly fills the tooth of the paper and loses the sparkling quality of the medium. Colour judgement is facilitated by trying out a colour on a strip of the same paper that you are using, before applying it to the painting. The tone of a colour is affected by the choice of the paper. For example, a pale colour on a dark paper will look more contrasty and intense than on a pale paper. The colour of the paper plays a fundamental part in pastel painting. Sometimes areas of paper are left uncovered and become part of the painting. Exciting colour results can be obtained by the choice of paper: red pastel painted on to yellow paper, for example, will be very vibrant.

4

Backing Use a drawing board which is perfectly smooth, or insert several layers of paper under your painting, otherwise irregularities will show up on the surface as the pastel is applied and can be distracting. Work at an angle to allow loose particles to fall off, a folded trough of paper attached to the bottom of the board is useful as a catcher.

You can commence a pastel painting by drawing with a Conté pencil, charcoal or ink, or by drawing with a brush and watercolour or thin acrylic. Fig. 6 is a detail from the lower colour picture on page 128. The sketch was drawn with a brush and watercolour and areas of dark tone indicated. I approach pastel painting in the same way as oil painting, by starting with a thin underpainting. Pastel is built up on top, and some of the tinted paper or tonal underpainting is allowed to show through.

5

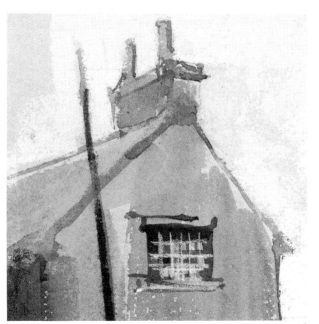

6

In Fig. 6 the window is painted with a brush and watercolour, the bars are superimposed on the watercolour with a white pastel pencil. Some of the panes are filled with grey pastel and some left as a dark tone of watercolour.

Watercolour and gouache

Watercolour painting demands bravery, a willingness to experiment, and mental preparation for the many failures that are inevitable. It is a difficult medium but very worthwhile when suddenly you find that the painting is working well, when the pigment is flowing with ease and drying to give exactly the desired effect. It is a fluid, elusive medium and, like the sea, can be unpredictable.

Watercolour materials

Paint Transparent watercolour is pigment combined with gum arabic, it is manufactured in tubes or pans and colours can be purchased individually or in sets. I recommend artist's quality where possible, especially if you are using pans.

Brushes Good sable brushes are the best, they come to a fine point and hold plenty of pigment, but ox hair or squirrel hair are reasonable substitutes. Do not leave brushes standing in water, shake off excess water and gently re-shape the bristles to a point between your finger and thumb.

Palette Choose a watercolour box with deep wells or use white saucers.

Paper There are many watercolour papers to choose from, it is best to experiment and find which weight and texture suits you best. Some watercolour papers are tinted but it is usual to paint on a white surface to allow light to reflect through the transparent pigment and to exploit the luminosity of the medium. Areas of white paper can be left untouched to act as highlights.

Stretching Heavy paper can be pinned or clipped to a board, thinner paper can be stretched to prevent the surface from cockling. To do this use a drawing board which is a little larger than the piece of paper. Soak the paper in a bath or tray of clean water. Meanwhile prepare four strips of gummed paper tape slightly longer than each side of the paper. Lift the paper out of the bath and allow excess water to drip off then lay the paper on the board and fix all four sides down to it with the gummed paper strips. Keep the board flat and allow the paper to dry naturally but out of direct sunlight. The length of time will vary according to the atmosphere and thickness of paper.

2

Techniques

Have ready plenty of clean water in large pots (this does not mean that you necessarily paint with a lot of water in the brush). Allow for watercolour to be several tones lighter when it is dry: compare a dab of colour wet on the palette and dry on the paper, for the difference can be considerable.

Beginners can try a few brush control exercises and doodles to get used to drawing with a brush. Try holding the brush vertically and paint fine lines with the tip just touching the paper (Fig. 1). With a little more pressure on the paper a wider brush mark will result (Fig. 2). Large areas can be filled with the brush held almost horizontal to the surface so that the whole length of the hairs is in contact with the paper (Fig. 3). Dry brush effects can be gained by gently squeezing watercolour out of the brush between finger and thumb and then dragging the brush across the paper (Fig. 4). A large no. 10 sable was used for all these diagrams.

3

1

4

134

Wet in wet Mix plenty of colour before commencing a wash. Damp the paper slightly with clean water from a sponge, and then brush on colour. A second colour brushed on before the first has dried will give soft-edged atmospheric effects.

Hard edge A precise edge can be achieved if you paint on a dry surface. In Fig. 5 a soft wash was laid and allowed to dry. A second wash was superimposed and also allowed to dry before any subsequent darker washes were superimposed.

Hard edges can also be achieved with the use of special masking tape or fluid. Masking fluid is a rubber solution which can be applied to the paper with pen or brush. (Brushes used for masking fluid should be washed out immediately after use.) When it is dry painting can commence, the paper beneath the masking remaining untouched by the washes. Once the washes have dried the masking can be rubbed off with a clean finger. Fig. 6 is a detail from the painting on page 88 showing the use of masking to create hard edges on the sails.

Gouache materials

Gouache is opaque watercolour and can be obtained in tubes, jars or solid disks but the best quality (designer's gouache) is in tubes.

Brushes The same as for transparent watercolour, also hog hair brushes.

Palettes China palettes or white saucers.

Supports Watercolour paper, pastel paper, heavy cartridge paper, mount board, cardboard.

Techniques

Gouache can be used opaquely straight from the tube, or mixed with water to give degrees of opacity. Undiluted paint can also be dragged over the support to give a broken paint surface which allows the paper colour to show through. A small amount of water added to gouache can produce a velvety surface texture, more water will produce a creamy consistency which brushes onto the paper to give a different quality of surface. More water still gives a milky quality to the paint.

The tone of a gouache colour can change as the paint dries depending on how much water has been used in the mixture. There is very little change if the paint is kept as dry as possible.

Gouache can be used in conjunction with transparent watercolour or ink, pastel or wax crayons. It is a versatile medium and dries quickly.

Fig. 7 The detail from my painting of Norfolk Boats on page 17 shows a variety of techniques. There are areas of thin transparent paint, areas of paint applied in thick slabs, thick paint dragged over the surface to give a broken effect and lines of rigging that have been incised.

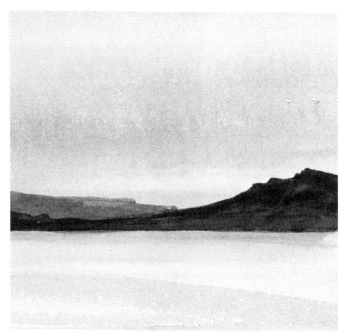

5

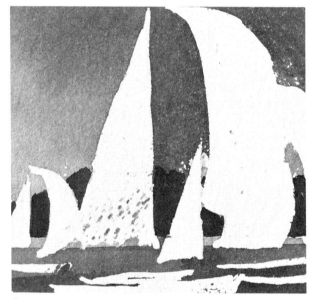

6

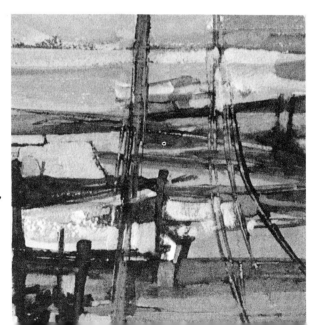

7

Oils and acrylics

The technique of oil painting has been in use since the early fifteenth century. The pigment, which is the same as in watercolour or pastel, is bound with oil and remains moist and workable for some time. I believe that it is one of the easiest mediums for the beginner to use: it can be pushed around, wiped off, repainted – even left for a while for reconsideration.

Materials

Supports Canvas, hardboard, wood, chipboard, strawboard, heavy cardboard, copper or aluminium sheet, oil paper. All surfaces except the metal have to be sized and primed to make them impervious to oil.

Easels There are many types available – or simply lean a drawing board against the back of an old chair.

Palettes Usually wood (treated to be impervious to oil), glass or tear-off greaseproof paper palettes.

Brushes Good hog hair brushes, house painting brushes and a long sable brush for painting the details.

Palette knives For mixing paint on the palette, applying paint to the support or scraping it off.

Medium There are many kinds obtainable which can be added to the oil paint if it needs to flow more easily or to accelerate drying time. Spirits of turpentine or turpentine substitute can be used to thin paint.

Be methodical and clean up after each painting session with turpentine substitute or paraffin (kerosine in the USA) and plenty of rags. Brushes especially should be rinsed in turpentine and then washed with soap and water. Work up a lather with the brush on the palm of the hand and rinse. Repeat until all colour has come out of the brush.

Dippers Small metal cups or glass jars for holding mediums.

Techniques

It is not possible to mention them all.

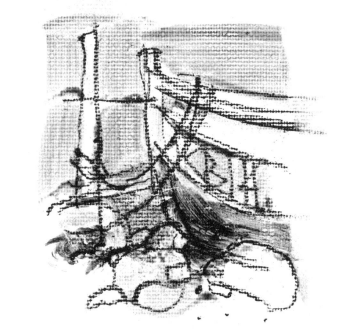

1

Fig. 1 This is drawn with charcoal and fixed. Thin washes of oil paint are then brushed over the top to establish the distribution of colour and tone. When this is dry, thicker paint is built up gradually.

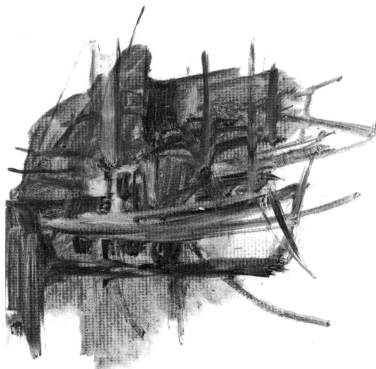

Fig. 2 A thin underpainting is brushed over the support and then the subject is 'drawn' with a brush and darker paint. Alterations are made by wiping paint off with a turpsy rag. A full tonal range is established and left to dry. Thicker paint is then applied.

2

Fig. 3 Impasto: thick paint applied with a knife (or brush) over a dry underpainting (which may be allowed to show through in places). The raised rough surface of the paint can catch the light and give life to the surface of the painting.

Fig. 4 Alla prima: This is a direct wet-in-wet application of thick paint without any preparation of the support. A spontaneous technique.

Fig. 5 This detail from *Floats* on page 69 shows underpainting visible in some areas, dark tones strengthened and light tones built up with impasto.

Oil paintings can be protected by varnishing, but not until 6–12 months after completion when the paint has thoroughly dried out.

Acrylic materials

Acrylic colours are obtainable in tubes. The paint consists of pigment bound with synthetic resin. Fresh paint is soluble in water but once dry is waterproof and as permanent as pastel. Unlike oils, acrylics dry quickly. Thick paint can safely be built up in layers, or thinned and brushed on as a glaze.

Supports Any grease-free dry surface can be used without preparation. If a primer is used it must be an acrylic primer.

Brushes Oil or watercolour brushes. Wash in warm water immediately after use.

Medium Various kinds obtainable as extenders, to give gloss or matt textures, or to retard drying.

137

Pencils and Conté pencils

Materials

Graphite pencils Graded from 8H (very hard) through HB (medium) to 8B (very soft). Softer grades are more sensitive for drawing, hard grades give finer lines but cannot be so easily erased.

Charcoal sticks These are of differing thickness and hardness. A good medium for quick tonal sketches, but it smudges and rubs off easily so should be sprayed with fixative.

Charcoal pencils Compressed charcoal in pencil form which can be sharpened and used for more detailed charcoal drawing.

Conté pastel pencils Hardened pastel in a pencil form, obtainable in a variety of colours, for drawing and for adding details to a pastel painting.

Paper Cartridge, Ingres, smooth card.

Erasers Soft or putty erasers are best as they do not damage the paper.

Techniques

Drawing is the use of line, whatever the method. Thin and thick lines come from a different hardness of pencil or from varying pressure on the paper. Tone can be created out of line by building up a series of lines (scribbled or cross-hatched) or by rubbing.

Pencil Drawings can be made over a watercolour wash or on toned paper. Highlights can be added to a pencil drawing on toned paper with white Conté pencil.

Charcoal See pencil. Alternatively, you can shade an area with charcoal and then draw into it with an eraser to create light tones.

Conté pastel pencils Black, brown and red Conté on a tinted paper, with white Conté for the highlights, are a traditional drawing technique. (The red referred to is a reddish-brown.) These and other colours can be used on white or tinted paper.

Fixative Most drawings require fixative to prevent smudging or offsetting onto other sheets of paper, especially in a sketchbook.

Many of my drawings that appear in this book were made with Conté pencil. It is a direct and sympathetic drawing medium which can give sensitive light lines or very strong darks. In my sketch of Wemyss Bay, east Scotland, I used a dark grey Conté pencil and indicated strong colour changes with red.

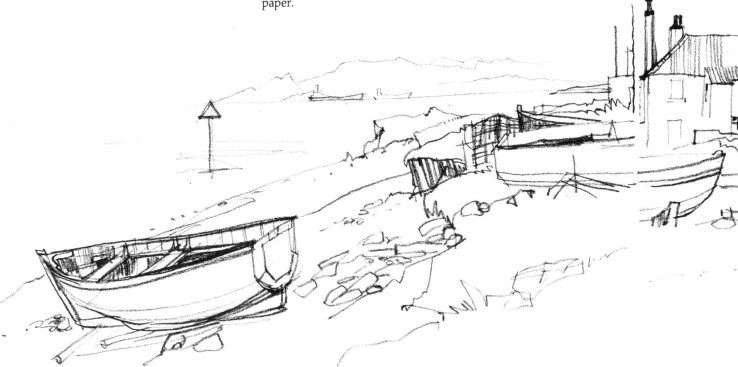

Development of a drawing

A drawing can be an idea for a painting, a quick composition sketch, a record of lighting effects, a reference sketch with colour notes or a finished work. The time spent on a drawing does not matter – it is possible for a two-minute scribble to provide enough stimulus for a future painting.

I keep all my old sketchbooks. I find that the images remain fresh and can spark off new ideas many years later. Quite often a different perception emerges after the passage of time.

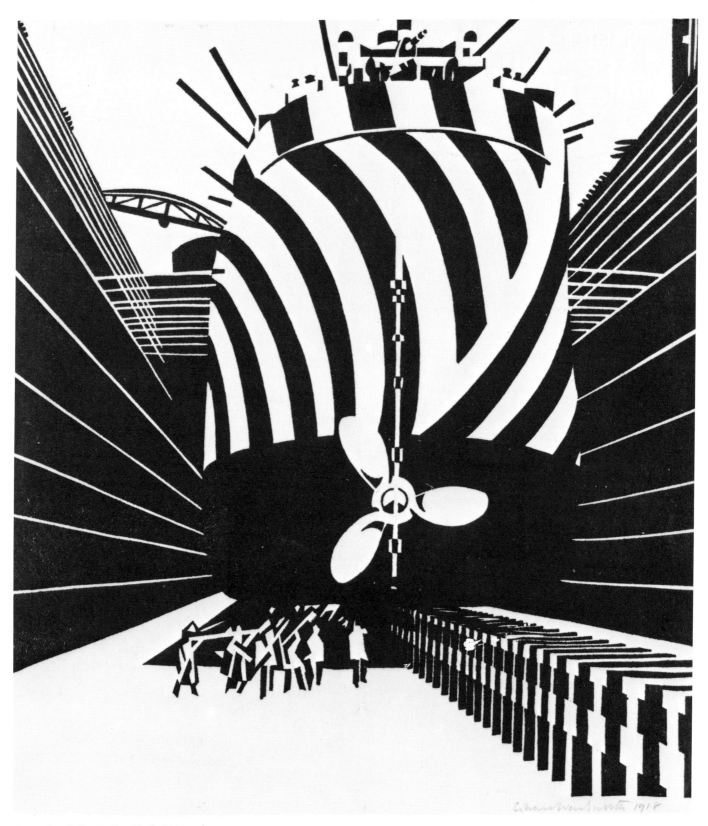

Camouflaged Ship in Dry Dock, Liverpool,
1918, woodcut by Edward Wadsworth

140

Conclusion

In preparing this book I set out to give an introduction to the many possibilities and to point out some directions for further study and development. An interest in painting boats is not a limiting experience; the subject can be treated in any way that interests you personally: detailed, impressionist or abstract. I have included many different kinds of boat and demonstrated a variety of painting and drawing techniques in order to convey my own enthusiasm and to whet your appetite for a subject which lends itself to a wide range of interpretation. Be prepared for disasters along the way. When painting has become an easy exercise, the time has come to abandon the tried and trusted techniques and to start out on a new venture, whatever the pitfalls.

The book inevitably states my own way of working, my love of drawing and my firm belief that drawing is essential to painting. I also believe in drawing as often as possible, and indeed painting as often as possible on location, in order to build up knowledge that only the experience of 'seeing' by drawing and painting at first hand can provide. I hope that I have been able to resolve some of the difficulties encountered in the drawing of boats by the artist who likes to include them in his paintings.

Only practice will develop the co-ordination of hand and eye which will enable you to record your subject. When the techniques of drawing and painting can be applied without too much preoccupation with the mechanics, the more concentration can be focused on what you feel about the subject. Copy some of the examples and ideas in this book if you wish, and any other work that interests you, but do so as a means of enquiry, with a view to developing your own way of thinking and painting.

Book List

The Artist's Manual, Macdonald Educational, London

Norman Battershill, *Painting and Drawing Water*, A & C Black, London; Van Nostrand Reinhold, New York

Edward Betts, *Creative Seascape Painting*, Watson Guptill, New York

John Blockley, *Learn to Paint with Pastels*, Collins, London

John Blockley, *The Challenge of Watercolour*, A & C Black, London; Watson-Guptill, New York

Roger Finch, *Sailing Craft of the British Isles*, Collins, London

William Gaunt, *Marine Painting*, Viking Press, New York

Fred Gettings, *Techniques of Drawing*, Orbis Publishing, London

Rowland Hilder, *Expressing Land, Sea and Sky in Watercolour*, Watson-Guptill, New York

Moira Huntly, *Draw in Brush and Ink*, A & C Black, London

Kenneth Jameson, *Painting, a complete guide*, Nelson, London

Kenneth Jameson, *You can draw*, Studio Vista, London; Taplinger, New York

John Lewis, *Rowland Hilder, Painter and Illustrator*, Barrie & Jenkins, London

Michael Pope, *Introducing Oil Painting*, Batsford, London

John Raynes, *Painting Seascapes*, Studio Vista, London; Taplinger, New York

John Raynes, *Painting Seascapes, A Creative Approach*, Watson Guptill, New York

John Raynes, *Starting to paint with Acrylics*, Studio Vista, London; Taplinger, New York

Ernest Savage, Pastels for Beginners, Studio Vista, London; Taplinger, New York

Karel Teissig, *Drawing Techniques*, Octopus Books, London

Gerald Wilkinson, *The Sketches of Turner RA*, Barrie & Jenkins, London

Bayeux Tapestry

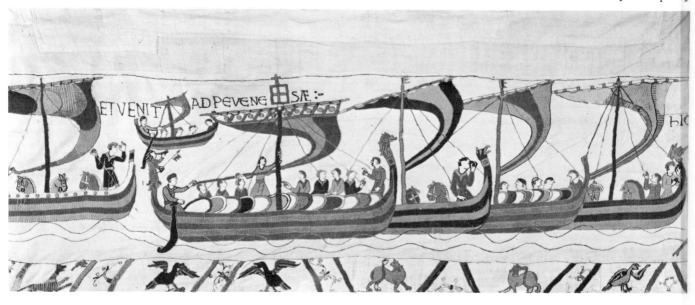

142

INDEX